GRAY IS THE COLOR

AN EXHIBITION OF GRISAILLE PAINTING

XIIIth-XXth CENTURIES

ORGANIZED BY THE INSTITUTE FOR THE ARTS

RICE UNIVERSITY

RICE MUSEUM, HOUSTON, TEXAS

OCTOBER 19, 1973 to JANUARY 19, 1974

Acknowledgments

I am grateful to J. Patrice Marandel who had the idea for an exhibition of grisailles.

I am indebted to the scholars who gave us valuable information regarding specific works—Harry Bober, Douglas Cooper, Jacques Foucart, José Frèches, Julius Held, B.J.A. Renckens, Claudie Ressort, Kent Sobotik, Charles Sterling, David Sylvester, and Philippe Verdier, and to artists who were likewise helpful—Richard Artschwager, Robert Indiana, Jasper Johns, Man Ray, James Rosenquist, Hedda Sterne, and John Willenbecher.

I am also grateful to the following for their lively interest in the exhibition and their cooperation: Otto Karl Bach, Director, The Denver Art Museum; John I.H. Baur, Director, Whitney Museum of American Art; Thomas Beckman, Registrar, Milwaukee Art Center; Victor Beyer, Conservateur du Musée des Beaux-Arts de Strasbourg; Raymond Blanc, Conservateur des Musées du Mans; Diane DeGrazia Bohlin, Curator of European Art, The Denver Art Museum; R. Boisdé, Député Maire de la Ville de Bourges; Charles E. Buckley, Director, The St. Louis Art Museum; Jean Cailleux, Paris; David G. Carter, Director, The Montreal Museum of Fine Arts; Leo Castelli, New York; Anthony M. Clark, Curator in Charge, Department of European Paintings, The Metropolitan Museum of Art; Ralph T. Coe, Assistant Director, Nelson Gallery-Atkins Museum; Curtis G. Coley, Director, John and Mable Ringling Museum of Art; Isabelle Compin, Service de Documentation du Département des Peintures, Musée du Louvre; Françoise Debaisieux, Conservateur, Musée des Beaux-Arts de Caen; Mrs. Leo J. Dee, Curator of Drawings, Prints and Paintings, Cooper-Hewitt Museum of Decorative Arts and Design; Danielle Demetz, Inspection générale des Musées classés et controlés de France; Moussa M. Domit, Acting Director, North Carolina Museum of Art; James Elliott, Director, Wadsworth Atheneum; Everett Fahy, Director, The Frick Collection, New York; Jean Favière, Conservateur des Musées de la Ville de Bourges; Joy Feinberg, Registrar, University Art Museum, Berkeley; Martin Friedman, Director, Walker Art Center; Roger Gaud, Conservateur du Musée Goya, Castres; Henry Geldzahler, Curator of Twentieth-Century Art, The Metropolitan Museum of Art; Jane Hayward, Associate Curator, The Cloisters; James J. Heslin, Director, The New-York Historical Society; Henry Hopkins, Director, Fort Worth Art Center Museum; Thomas Hoving, Director, The Metropolitan Museum of Art; Betsy Jones, Curator, Painting and Sculpture, The Museum of Modern

3

Art; Frances Follin Jones, Curator of Collections, The Art Museum, Princeton University; Klaus Kertess, Bykert Gallery, New York; Michel Laclotte, Conservateur en Chef du Département des Peintures, Musée du Louvre; René Le Bihan, Conservateur du Musée Municipal de Brest; Jean Lecanuet, Sénateur-Maire, Rouen; Herman W. Liebert, Librarian, The Beinecke Rare Book and Manuscript Library; G. Lombard, Sénateur-Maire, Brest; Peter O. Marlow, Chief Curator, Wadsworth Atheneum; Louis L. Martz, Director, The Beinecke Rare Book and Manuscript Library; François Mathey, Conservateur en Chef du Musée des Arts Décoratifs; Philippe de Montebello, Director, The Museum of Fine Arts, Houston; Francis J. Newton, Director, Portland Art Museum; Richard Oldenburg, Director, The Museum of Modern Art; Hervé Oursel, Conservateur des Musées d'art et d'histoire de Lille; Jean Paladilhe, Conservateur du Musée Gustave Moreau; Dominique Ponnau, Chef de l'Inspection générale des Musées classés et controlés de France; Olga Popovitch, Conservateur des Musées de Rouen; Pierre Quarré, Conservateur en chef du Musée des Beaux-Arts, Dijon; Daniel Robbins, Director, Fogg Art Museum; Christian Rohlfing, Administrator, Cooper-Hewitt Museum of Decorative Arts and Design; Pierre Rosenberg, Conservateur au Département des Peintures, Musée du Louvre; Fernande E. Ross, Registrar and Curator of the Intra-Loan University Collection, Yale University Art Gallery; Leo Rosshandler, Assistant Director, The Montreal Museum of Fine Arts; William S. Rubin, Chief Curator of Painting and Sculpture, The Museum of Modern Art; Samuel Sachs, Acting Director, The Minneapolis Institute of Arts; Marie-José Salmon, Conservateur du Musée Départemental de l'Oise; Jack Schrader, Curator, The Cloisters; Peter Selz, Director, University Art Museum, Berkeley; Alan Shestack, Director, Yale University Art Gallery; Laurence Sickman, Director, Nelson Gallery-Atkins Museum; Richard E. Spear, Director, Allen Memorial Art Museum; David Steadman, Acting Director, The Art Museum, Princeton University; Lisa Taylor, Director, Cooper-Hewitt Museum of Decorative Arts and Design; Richard Stuart Teitz, Director, Worcester Art Museum; Martine Tissier de Mallerais, Conservateur des Musées de Blois; Barbara Toll, Hundred Acres Gallery, New York; Marjorie G. Wynne, Research Librarian, The Beinecke Rare Book and Manuscript Library.

The catalogue owes a great deal to the knowledge, expertise and dedication of Harris Rosenstein, Executive Administrator of the Institute for the Arts. Thanks are also due to Susan Barnes and Molly Kelly, who did research as well as editing. Shelby Miller, Art Librarian, Geri Edwards, and Victoria Sharman were most helpful. Jim Love and L. D. Dreyer and his crew proved as usual to be my indispensable collaborators for the installation.

<div align="right">DOMINIQUE DE MENIL, Director</div>

Contents

Lenders to the Exhibition

Allen Memorial Art Museum, Oberlin College
The Art Museum, Princeton University
The Beinecke Rare Book and Manuscript Library, Yale University
Tom and Dana Benenson, Mill Valley, California
Edmund Carpenter, New York
Cooper-Hewitt Museum of Decorative Arts and Design, New York
The Denver Art Museum
Louise Ferrari, Houston
Fogg Art Museum, Harvard University
Fort Worth Art Center Museum
Galerie Heim, Paris
Alexandre Iolas, Inc,. New York, Geneva, Milan, Paris
Jean Lafond, hon. F.S.A., Paris
Mark Lansburgh, Colorado Springs
Suida Manning Collection, New York
Mr. and Mrs. Edward A. Maser, Chicago
Mr. and Mrs. Judd Maze, New York
Adelaide de Menil, New York
D. and J. de Menil Collection, Houston
Menil Foundation, Houston
The Metropolitan Museum of Art, New York
The Metropolitan Museum of Art: The Cloisters Collection
Minneapolis Institute of Arts
The Montreal Museum of Fine Arts
Musée Départemental de l'Oise, Beauvais
Musée des Arts Décoratifs, Paris
Musée des Beaux-Arts, Brest
Musée des Beaux-Arts de Caen
Musée des Beaux-Arts, Dijon
Musée des Beaux-Arts, Lille

Musée des Beaux-Arts de Rouen
Musée des Beaux-Arts de Strasbourg
Musée du Louvre, Paris
Musée Goya, Castres
Musée Gustave Moreau, Paris
Musées de Blois
Musées de la Ville de Bourges
Musées du Mans
Musées Nationaux de France
The Museum of Fine Arts, Houston
The Museum of Modern Art, New York
Nelson Gallery-Atkins Museum, Kansas City, Missouri
The New-York Historical Society
The North Carolina Museum of Art, Raleigh
Henry Pearson, New York
Portland Art Museum, Oregon
John and Mable Ringling Museum of Art, Sarasota, Florida
A.M. Sachs Gallery, New York
The St. Louis Art Museum
Spencer A. Samuels and Company, Ltd., New York
Pete and Lesley Schlumberger, Houston
Schweitzer Gallery, New York
University Art Museum, Berkeley, California
Wadsworth Atheneum, Hartford, Connecticut
Walker Art Center, Minneapolis
Whitney Museum of American Art, New York
Worcester Art Museum, Massachusetts
Yale University Art Gallery
Five Private Collections
Two Anonymous Lenders

La couleur affaiblit.

—Picasso

Quoted by André Malraux in *La tête d'obsidienne* (Paris: Gallimard, 1974), p. 145.

Foreword

Eugène Delacroix said that "a picture should be above all a feast for the eye."[1] This is a sobering reminder to a grisaille exhibition. Gray, associated with mourning in European tradition, can hardly convey the idea of a feast, let alone the sumptuousness that paint and painting suggest. Yet Odilon Redon wrote about Rubens: "a simple grisaille of his contains as much as the final work."[2]

Grisaille, indeed a limited medium, provides a rigorous test of talent. Stripped of color, deprived of any sensuous charm, the art of painting appears in its nakedness. It is reduced to the subject, the composition, the authority of the brushstroke, and the style.

Without drawing a parallel between photography and painting, it is important to remember that Henri Cartier-Bresson, the greatest living photographer, refuses to make color photographs. This decision should not be interpreted as an attitude of austerity. There is a subtlety and richness in blacks and whites and grays, next to which color may appear coarse and vulgar. Redon again, praising the palette of Fantin-Latour, whom he calls a "clairvoyant disciple of Delacroix," admits that it does not provide "this fundamental gray which differentiates the masters, which expresses them, and which is the soul of any color."[3]

Though obviously limited in scope, the present exhibition offers a historical panorama for the study of pictorial problems. In a way it is an art historian's show. Yet it is also a show for the amateur, for the dreamer. Gray provides a silent language. Used by Barnett Newman for his *Stations of the Cross,* it reaches the utmost poignancy.

In the autobiography of Girolamo Cardano, the XVIth-century Italian physician and mathematician, visions and dreams hold an important place. In the latter part of his life, Cardano could still remember a dream he had as a child: "images of castles, of houses, of animals, of men of diverse costumes and varied dress; images of flute-players, even, with their pipes, as it were, ready to play, but no voice or sound was heard . . . innumerable objects . . . flowers of many a variety, and four-footed creatures and diverse birds . . . but in all this exquisitely fashioned pageant there was no color. . . . "[4]

In our own time, a young girl who had suffered from schizophrenia described her distressing sensations to her doctor as a loss of color; trees, houses, people, everything had turned gray. This clinical observation and the

9

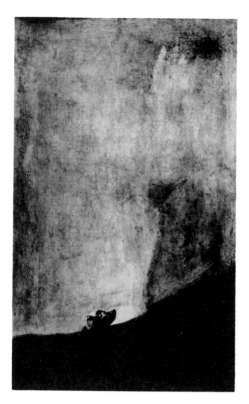

Goya. *Dog,* 1821-22. Prado, Madrid.

previous dream description remind us that a gray painting may be more than a painter's exercise. If indeed they are not meant as quick notations, models for engravers, classicistic simulations of bas-reliefs, or studies of values, gray paintings are intrinsically disquieting: they seem to introduce us to a world of dreams, of anguish, of alienation. Among Goya's paintings of the *Quinta del Sordo*, grays predominate in that of a solitary dog peering up into a vast nothingness—a work which has been described as "one of the strangest pictures in the whole history of Spanish painting, and one of the most surprising paintings anywhere in the world before post-1900 Expressionism."[5]

Night scenes, which come close to grisailles when they make their first known appearance in manuscripts (the *Belles Heures du Duc de Berry*), participate in the genre. The invasion of painting by nocturnal themes goes

hand in hand with a taste for the bizarre, the melancholy, the visionary. A late Mannerist painter, François de Nome (previously known as Monsu Desiderio), painted obsessive nightscapes of black skies and surreal architecture in creamy and gray tones which are scenes of imminent or actual catastrophes.

What we see and what we hear are closely connected—like thunder and lightning. We talk of loud and of mute colors. The Italian Futurist, Carra, wrote a manifesto in favor of the painting of sound in which he condemned "gray and muddy tones."[6]

Giacometti, who was forever trying to capture an ever evasive reality, drastically limited his palette to grays, with just traces of washed out pinks, muddy blues and yellows. This retreat from color translated his feelings of remoteness and mystery. He confessed in an interview with Pierre Schneider that at times he had "the impression of being in front of something never seen, a complete change of reality. . . ." Waking up in his room he found that "everything had the appearance of an absolute immobility. A sort of inertia, a loss of weight. . .an impression of silence."[7]

Gray is deceptively simple. This exhibition should reveal part of its complexity. It spans extremes: from impersonal objectivity to spiritual statements, from free painterly expression to rigorous tonal constructions. Whatever its use, whether rhetorical or spontaneous, gray challenges the virtuoso and invites the visionary. It has attracted some of the most original painters of our time: Picasso, Barnett Newman, Magritte, Jasper Johns.

<div style="text-align: right">D. de M.</div>

1. As quoted by Arnold Hauser, *The Social History of Art,* vol. III. (New York: Vintage Books, 1957), p. 221.

2. Odilon Redon, *A Soi-Même* (Paris: Librairie José Corti, 1961), p. 80.

3. *Ibid.,* p. 156 (my translation).

4. Jerome Cardin, *The Book of My Life (De Vita Propria Liber)* [1575], trans. Jean Stoner (London: J.M. Dent and Sons, 1931), pp. 147-48.

5. José Gudiol, *Goya,* trans. Kenneth Lyons, vol. I, (Barcelona: Ediciones Polígrafa, S.A., 1971), p. 344.

6. Carlo Carra, "Manifeste futuriste" [1913], reprinted in the catalogue of the exhibition *Le Futurisme, 1909-1916* (Paris: Musée National d'Art Moderne, Sept. 19-Nov. 19, 1973), p. 108.

7. "My Long Walk," *L'Express* (Paris), June 8, 1961; translation by Anna Seldis printed in the catalogue of the exhibition *Alberto Giacometti, Lithographs and Etchings* (Beverly Hills, Cal.: Frank Perls Gallery, Nov. 2-Dec. 23, 1970), p. 3.

Introduction

Grisailles, which may be gray or colored monochromatic paintings, are generally objects of curiosity rather than of high admiration. Monochrome appears, at least superficially, to be a more or less arbitrary reduction in possibilities when compared to fully chromatic painting; furthermore, the various reasons for its use are a recondite matter. This exhibition, spanning the centuries from the XIIIth down to the XXth, offers selective encounters with the subject and is intended to inform more generally about some of the historical uses of grisaille—although practical limitations on its scope have made the exhibition far from exhaustive—and to indicate that monochrome is a reduction capable of extraordinary visual richness and conceptual possibilities.

It is only in modern times that painters have used monochrome independently of religious purposes, academic methods, or art diffusion processes, and instead for its metaphoric possibilities or its intrinsic affective qualities. Its attraction is such that even in the 1960s, while American formalist abstract painting and its criticism developed a unique emphasis on color as against light-and-dark structuring of a composition (considered residually illusionist), a number of artists with varied intentions made the reduction to monochrome, and grisaille as a genre has recently enjoyed an interesting and revealing revival. And considering a greater time span in this century, for ''black-and-white'' painting, as we understand the term in a context ranging from Picasso's *Guernica* to Franz Kline's work in this mode (a context distinct from traditional grisaille with its modeled forms), we have a fine appreciation by Max Kozloff:

Here the Manichean contrasts, the value jumps, the boldness and immediacy of drawing, the very extremity of the achromatic colors, all contribute to give a picture of the primordial vocabulary of art itself. Further, the combination of black and white is an irreducible quotient, less than which the idea of visual relationships can scarcely exist.[1]

Even Rothko, who rested so much weight on color and a supreme discrimination in its use, produced at the end of his life a series of black-and-gray paintings that are among the most poignant of his career.

Gray is a ''sad'' color in Western culture, one associated with death and mourning. In XVth-century Germany, grisailles were often eloquently referred to as *Totmalerei*—lifeless paintings. Originally, it seems, grisaille had a

13

symbolic significance in medieval liturgy. In an important essay, Molly Teasdale Smith has convincingly stressed the relationship between the early use of monochromatic painting and liturgical practices,[2] a relationship suggested by certain altar hangings painted in gray—the color of ashes—which were used during the penitential season of Lent. Smith's primary example of the genre, the grisaille *Altarcloth of Narbonne,* now in the Louvre, was painted in the last quarter of the XIVth century. The inventories of Charles V, made in 1379, describe a rather similar piece and specify its use for *caresme cothidianes,* or daily Lenten observance. The iconography of the *Altarcloth of Narbonne* is centered around the theme of the Passion of Christ: the central image represents the Crucifixion, while the extreme right and left are, respectively, scenes of the Passion (Christ Carrying the Cross, the Flagellation, the Kiss of Judas) and the Resurrection (the Entombment, Descent into Limbo, and the *Noli me tangere).* The altarcloth could therefore be compared to a scroll presenting the entire cycle of the Lenten and Easter liturgy from left to right. Smith has noted that, given this iconography, the altarcloth was more likely hung above and behind the altar, rather than below and in front of it as has been believed.

In some cases stationary painted panels, rather than cloths, were used in the same position. Liturgical ordinances required that these be "closed" on ordinary days and revealed only on feast days. Tradition further stipulated that *all* ornaments in the church had to be removed or covered during the Lenten season, a practice still in use which symbolizes that, during His Passion, the divine nature of Christ was hidden. It is possible that the need to change these panels to fulfill this requirement gave rise to the winged stationary altarpieces which began to appear as early as the XIIIth century. Their wings could easily be closed for Lent, thus hiding the brilliantly polychromed interior images. Smith notes further that the exterior paintings, visible when the polyptychs were closed, were often rendered in dull colors, providing a striking contrast to the interiors. She finds this fact significant in view of a number of grisaille panels that first appeared in Flanders in the early XVth century and whose type spread through Europe (cf. nos. 9 and 10, The Art Museum, Princeton University). The earliest known examples are works by the Master of Flémalle and Jan van Eyck. The panels are almost invariably located on the exterior wings of triptychs or polyptychs. The fact that a frequent theme of such grisailles is the Annunciation—a feast which occurs during Lent—lends credence to Smith's theory that the use of grisaille acquired religious significance during the XIVth and XVth centuries.

Early grisaille panels, those of Van Eyck for example, have been noted as simulating stone sculpture. It is true that in their decorative use through the

centuries, grisailles were often meant to give the illusion of sculpture. Significantly, however, as Smith has remarked, in the early XVth century all sculpture—stone as well as wood—was painted; this representation of unpainted sculpture must therefore have appeared at the time unfinished. This seeming austerity could have provided an even more suitable "mood" for the liturgy of Lent.

Furthermore, as Professor Harry Bober noted, grisaille development in the Gothic period may be interpreted in relation to philosophical and theological developments. He terms the change which distinguishes pre-Gothic from Gothic art as fundamental and a radical break (whatever the continuity):

Before the Gothic period light was the quintessential symbolic expression of divinity—by means of the analogy of light it was most perfectly possible to give humanly intelligible expression to such ideas as (1) the essential immaterial nature of the transcendental essence of divinity—"the light beyond the sun," the primordial essence of cognition; (2) the otherwise inexpressible nature of the Trinity (one, yet three) by the analogy of three beams of light passing through three windows and yet remaining one light; and (3) how the Logos, without physical action or violence, enters the Virgin to become the Incarnate Christ. In this pre-Gothic ideology, LIGHT and COLOR were understood to be virtually the same manifestation—but only insofar as colors were at their highest purity and brightness. Hence, pictures showed no specific natural light (or shadow) but rather total illumination and an absolute (as if self-generated and universal) light; COLOR, concomitantly, was local (areas filled with one undifferentiated color of high saturation and intensity—clear, unmitigated and pretty much unmodulated). Variations and exceptions do not affect the principle as it was expressed and understood in its perfect forms.[3]

While in the XIVth century grisaille is an established fact of painting, Professor Bober continues, between the XIIth and XIVth centuries there seems to be a gap; he feels, however, that XIIIth-century practices simply prepared the ground that made grisaille possible and even inevitable in the XIVth century. It brought the basic stylistic changes from the pre-Gothic

to the Gothic shallow stage of spatial depth, modeled figures and now modeling of figures entire (i.e. one color could envelope an entire figure and, with its modulations, sculpture it with increasing relief). A kind of special medieval naturalism was born and unfolding rapidly. . . .The XIIIth-century "proto-Grisaille" may be seen in the *Vie de St. Denis* (BN fr.n.a. 1095, ca. 1250). This development is beautifully evident in the famous Morgan Library Picture Bible (M. 638; recently re-published as *Old Testament in Miniatures*, S.C. Cockerell). Here we see introduction of *muted* browns and grays, alongside the bright old colors; and individual figures are fully *modeled* in one color—thus, those figures wearing gray costumes are, in effect, individually grisaille, and we note angels (grisaille white), and dappled horses in grisaille.

All that remained was to follow through the implications of the *sculptural* potential that such modeling in one color was striving toward. Why such sculptural interest? It

was the positive aspect of the spatial expression—a stage created for the figures, and so the figures had begun to be more palpable as the actors on that stage. But why, in the Gothic period, did this interest arise anyway? Because the changes in philosophy in the XIIIth century made it proper and even desirable that man open his eyes to the single wonders of creation in terms of every single real thing in creation. Modeling of figures in one color gave those figures physical reality through the wholeness and continuity of the form—instead of the pre-Gothic "cartographic" divisions of a surface figure; chromatic continuity in subdued colors gave the figure relief and, by virtue of subdued colors, placed the figures in the new (if limited) space.[4]

Grisaille painting since the Gothic era appears as something of a paradox. On one hand it is more "realistic" than any other kind of painting, for it is often used to represent an actual object rather than a re-created scene. On the other hand, it also reaffirms the act of painting as a *cosa mentale* and reveals the illusionistic quality of this art—its necessary contradiction between real and pictorial space. Quite naturally, the restless minds of the Renaissance artists were to bring deeply "modern" and personal answers to the problems of monochrome. Late XVth- and XVIth-century grisailles in this exhibition, by Mantegna, Giulio Romano, and Heemskerck, differ fundamentally from those of earlier periods: the spatial relationship of the figures, the iconography of the scenes, the use made of grisaille within an ensemble or individually, are entirely different.

It would be unnecessary to stress here once again the importance of the rediscovery of Antiquity to all these artists. However, the impact of these new discoveries can be seen in grisaille even more clearly than in other pictures. It is as if, say, Mantegna were giving new life to the dead sculptures recently exhumed. Painting in grisaille allowed the painters of the Renaissance to show their superiority over the sculptors. A typical discussion of the time was indeed the supremacy of painting over sculpture: Leonardo for instance placed painting above sculpture, for sculptors, unlike painters, did not have to give the illusion of a third dimension. Paradoxically, the enthusiasm of the Renaissance painters for the *sculpture* of a previous civilization gave them the impulse to create original, totally illusionistic pictures and to prove their superiority to the sculptors not only of their time but also of the past. In some works of Mantegna—such as the *Triumph of Scipio* (London, National Gallery)—the introduction of a sculpture in a composition painted entirely in grisaille seems to reinforce this point: not only can painting simulate sculpture in the representation of actual people, but it can also simulate sculpture itself and thus make the illusion double.

It should be noted that some of the most inspired solutions brought to the problem of painting in monochrome came, as in the case of Mantegna, in the Venetian milieu of the late XVth century. Mantegna, involved in brilliant

colorism and equally with the question of light, presents in his grisailles a "negative" version of his own art in color, emphasizing subtle contrasts and deep shadowings.

Among the Venetian antiquarians and the Paduan scholars, the "magic of painting" was a theme often discussed. Zeuxis, Apelles, all the renowned Greek painters whose works were totally lost, exercised a spell on artists as well as connoisseurs. In the artistic literature of the period, anecdotes about these painters and the highly illusionistic quality of their art were recurrent. For the men of that generation these works of art, famous in their time but now vanished, were a challenge: it was up to them to re-create these paintings. Also, the superiority of painting over sculpture could be proved once more: sculptors, after all, had actual examples of Greco-Roman art available for their study; the painters had only the power of imagination.

Secular themes appeared in grisailles at that time. Their use was not reserved to any specific purpose. The range of representation became wider, with a preference for subjects drawn from the Bible or Roman history. It is conceivable that a clientele developed for paintings of this kind, whose "bizarria" would seem suitable for cabinets of curiosities. The collectors who bought and cherished Roman sculpture may easily have patronized the painters of works whose quality and refinement could compete with those of the past, or whose efforts aimed toward a re-creation of it. Perhaps this would be a way to explain the many works in grisaille that issued from the studio of Mantegna (cf. nos. 5 and 6, Montreal Museum of Fine Arts). It is easy to imagine them as decorations for a cultivated gentleman's library.

The imitation of sculpture—one of the functions of grisaille until the end of the XVIIIth century—made such painting most suitable as decoration for larger ensembles. Parmigianino, to take only one example among hundreds, used grisaille figures in his decoration of Santa Maria della Steccata in Parma. The vogue of monochrome soon invaded the decorative arts, stained-glass windows and enamels, indeed some of the finest being executed in this technique. Important artists did not look down on executing some purely decorative works in this manner: if we go from Italy to the Northern countries, we can take from this exhibition the example of Maarten van Heemskerck, whose remarkable panels (cf. no. 11, Allen Memorial Art Museum, Oberlin College, and no. 12, Yale University Art Gallery) once probably decorated a piece of furniture.

In the XVIIth and XVIIIth centuries, while grisaille continued to be used merely for decorative panels, overdoors imitating sculpture, trompe-l'œil of all kinds, and even, at the end of the XVIIIth century, for the making of

17

commercial wallpapers, large art works in monochrome are generally not to be found (an exception could be cited in the huge altarpieces by the Normand painter Jean de Saint-Igny, today in the museum in Rouen). Grisailles nevertheless abound in the art of that period. They can be found in almost every museum or collection, and they represent an important shift in the way the technique is valued. Usually small in size and swiftly painted, most of these grisailles are sketches, a part of the elaborate process that developed for the creation and the diffusion of a work of art at that time.

Rudolf Wittkower has noted that this habit of sketching a first thought for a composition rapidly and directly on the canvas also originated in Venice: "A great number of boldly executed oil monochromes on paper were made in Tintoretto's studio, mostly executed by Tintoretto's son Domenico, and this technique, in less sketchy form, was taken up in Bologna by the Carracci circle after about 1585."[5] It reached not only Bologna and the other parts of Italy but also the countries north of the Alps, France, Flanders, and the Netherlands. The most inventive geniuses of the North, Rubens and Van Dyck, both spent some time in Italy, and both adopted the brilliant technique of Venetian oil sketches, using in their small paintings the monochrome which had also a longstanding tradition in Northern art.

Like these sketches, works in grisaille were rarely considered works of art *per se*. They usually served some utilitarian purpose, for in the academic tradition that was developing then, the making of a picture involved not only the artist but also a patron, and occasionally—if the work was to be engraved—a public. Grisailles are thus often first ideas (*bozzetti*) jotted down by the artist, or models (*modelli*), either of the kind to be carried out by pupils or another artist working in a different medium (print, tapestry, gold, etc.), or those to be presented to patrons.

The fact that these works were first sketched in grisaille—which became an academic practice—emphasizes the importance given to composition rather than to color. There is even the paradox that some of the works which were going to be executed in full color were presented for the approval of patrons in this austere and somewhat reduced form—as if the painter kept the secret of his color as a surprise and final gift to his patron and his public. A sketch in grisaille was sufficient to prove the artist's ability to compose, model his figures, and set the accents of light and dark.

One of the most prominent uses of grisaille oil sketches was for engravings and for etchings: Rembrandt, Rubens, and the Baroque French and Italian painters generally painted *modelli* for this purpose. Professor Haverkamp-Begemann has noted that Rembrandt seems to have painted oil sketches only for etchings, never for paintings. Probably following the example of Rubens,

Rembrandt painted some of these sketches as models for pupils and largely to be executed by them; for other etchings he made sketches as an aid to himself in a novel method of creating painterly etchings. Haverkamp-Begemann remarks: "Rembrandt was forced to work on the copper plate in a manner that was the opposite of painting in oils on canvas or panel. . .he had to draw those areas on the red copper plate that would print dark and leave the plate blank for the highlights. In order to facilitate modeling with dark areas, he thus established the composition in the traditional way of the painter, that is by modeling primarily in light tones. In this manner he painted the final representation of a subject of which the details had already been established. These sketches, therefore, do not mark the beginning of a creative process; neither are they examples for others, but these are rather the last step before the final realization of the etchings."[6]

Rubens's sketches, on the contrary, were geared toward use by engravers of greater or lesser skill, so that the degree of finish of the sketch depended mostly on the ability of the engraver to understand the artist's ideas. *The Road to Calvary* (no. 22, University Art Museum, Berkeley), a highly finished sketch in which areas of dark and light are rendered with great care, perfectly exemplifies the case of Rubens leaving as little freedom as possible to his engraver (in this particular instance Paul Pontius). If one wants to take French examples, there are differing degrees of finish in the *modelli* by Pierre Jacques Cazes (no. 48, Musée de Caen) and François Lemoyne (no. 46, Musée de Strasbourg).

As in the XVIth century, small grisailles were collected during the Rococo period as amusing and rather charming oddities. In this exhibition, the paintings by the strange artist François Xavier Vispré (1730-1790; *Wandering Musicians,* no. 60, Musée de Dijon; *Two Beggars,* no. 59, private collection) or the small canvas of a young girl releasing a bird (no. 61, Pete and Lesley Schlumberger collection, Houston) inscribed "la Tromperie" (*The Deception*) are cases in point. All three are trompe-l'œil and painted depictions of a print (and so reasonably in monochrome) under broken glass. In *Wandering Musicians* Vispré carries the trompe-l'œil aspect a step further by representing an engraving of which part has been torn away, exposing a wood panel beneath it.

A concern with color seems to pervade the entire XIXth century. In his *Journal* Delacroix noted Alponse Karr's remark that "certain color harmonies produce sensations that even music cannot achieve."[7] The Impressionists later created a revolution in the rendering of light—and therefore of color.

If the pre-Romantic generation distrusted color (as it is so changeable, creating so many different responses in the spectator, it was far from being a positive factor in the search for an ideal beauty) and emphasized line and drawing instead, one could legitimately assume that the reductive process of grisaille painting would have appealed to them. Yet, at the same time, the decorative or trompe-l'œil aspects of the genre could not be further removed from their preoccupation. Ultimately there developed a certain contempt for this kind of illusionism which must be taken into consideration to understand the dearth of grisailles during that time. In the late XVIIIth century, the paintings of Dusillion (not in the exhibition) or of Sauvage (cf. no. 35, in the style of Sauvage, Musée des Arts Décoratifs, Paris) still belong to a strict tradition of decorative, illusionistic painting.

Studio practices throughout the century kept alive the academic tradition of painting monochrome sketches or grisaille versions of pictures. The strange allegory by Hennequin (no. 64, private collection) is an early example of the sort (although the final picture does not seem to ever have been executed, and the high finish of the preparatory painting may lead one to think of it as an autonomous picture); another one is the famous *Odalisque in Grisaille* (no. 62, The Metropolitan Museum of Art), once attributed to Ingres but now thought to be the work of a pupil with the possible collaboration of the master. That this picture may have been a "sketch" for an engraving is only a supposition—and, given its size, a rather unlikely one. The tradition of painting black-and white sketches for engravings remained alive, however: at the end of the century, Gérôme executed ten grisailles to be reproduced in photogravure (cf. no. 79, Schweitzer Gallery, New York), and quite naturally an artist like Gustave Doré painted many grisailles (cf. nos. 73-75), usually related to prints, but not always—as if he could not resist the fascination of monochrome.

It is well known that in the XIXth century photography variously influenced Realism and Impressionism in terms of realistic composition, painting a scene as it is encountered, and sketching by tone values. One may conjecture, although without confirming evidence, that the impress of photographic monochrome as a medium of inventive portraiture was a factor in Eugène Carrière's soft-focus achromatic portraits (cf. no. 84, Yale University Art Gallery), which in some examples suggest the blurry, dramatic close-ups made with reduced lighting to model the subject's features by the famous late XIXth-century photographer, Julia Margaret Cameron.

More academic works like Francis B. Carpenter's *Lincoln Family* (no. 72, The New-York Historical Society)—a "conversation piece" conventional in its precision, the stiffness of the figures, and its monochrome—recall early

portrait photographs. In fact, Carpenter did this painting from several photographs. On the other hand, the delightful *Mr. Ball Modeling the Statue of Barnum*, by H.E. Tidmarsh (no. 71, Menil Foundation), a work executed some twenty-five years later and most probably to be photographed for a magazine illustration, has the casual look of a snapshot. Finally, for Thomas Eakins—himself a remarkable photographer, so conscious of the camera's limitations that in the mid-1880s he drove himself to better Muybridge's techniques of photographing men and animals in motion—photography was a source of facts important to the conscientiousness of his work, just like his "wastefully" extended studies of anatomy and his cultivated interest in mathematics and science, which helped him correctly depict the effect of physical forces in nature. (Fairfield Porter explains his career as a tour de force: "he tried to make an art for a society that did not believe in anything but material facts. . . art acceptable to himself by the thoroughness of his learning and his practical skills. And so he puts the burden of disproof on the spectator, whom he challenges to find that this art, expressing the spectator's disbelief in art, is not valid."[8]) It is consistent with this conscientiousness that the grisaille version of his *The Fairman Rogers Four-in-Hand* (1889; no. 80, St. Louis Art Museum) was made to be photographed for Fairman Rogers's book *A Manual of Coaching,* since before the development of panchromatic film the values of colors did not photograph accurately.

An entirely different aspect of monochromatic painting in the late XIXth century can be seen in the work of the Symbolists, who were disaffected with the dominant naturalism of Realism-Impressionism. Redon, who was of the generation of the Impressionists, reacted against their emphasis on color and worked without it for almost twenty years. Of the way his monochrome pictures are structured in opposition to naturalism, Klaus Berger writes:

Black and gray are no longer gradations of tone between light and dark, they have become steps in the color scale and give the figure a chromatic existence. The light is no longer diffuse, it has no representational value. . . .There are sonorous black areas, the ground-bass so to speak, in opposition to which are set the white and gray areas of varying density and intensity. Outdoor light, an essential element of Impressionism, has been done away with, cast shadows have been lost, the picture has become a vision from which the lost remnants of perspective spatial depth have been banished. . . . [9]

The effect in Redon's *Profile of a Breton Woman* (no. 76, University Art Museum, Berkeley) is that what might have been picturesque has become majestic. Gustave Moreau, the central figure of the Symbolist movement, also disregarded Realist and Impressionist theories. His use of monochrome seems to tone down the mood of his subject matter. Intrinsically violent

images are seen through a haze that distances them from the spectator (cf. *Pasiphaë*, no. 70, Musée Gustave Moreau, Paris). The Symbolists were certainly the forerunners of Surrealism and were early to use monochrome for its affective qualities: their canvases are windows open on a world of dreams. Only Magritte will make this more explicit.

The diversity of XXth-century grisaille—in its aspects and intentions—reflects the complexity of modern art. A preoccupation with monochrome can be found in the work of Picasso as well as in Jasper Johns, in Magritte as well as in Albers. Echoes may be sensed from one artist to another, yet the variety of their answers commands a more acute attention to the phenomenon.

As to the disconcerting art of Magritte, it will perhaps be possible to prove some day that it is deeply rooted in the Flemish and Symbolist traditions. In a series of stony still lifes, landscapes, and interiors, Magritte treated the problem of grisaille by referring to both the tradition of simulated sculpture (seen at its best in the XVth-century Flemish panels) and the Symbolist interest in gray monochrome to convey a particular psychological mood. Gray, the color of dreams, becomes with Magritte the color of memories. The *Souvenir de Voyage* pictures (no. 96, Adelaide de Menil; no. 97, The Museum of Modern Art) more than any others by Magritte, take the spectator into another realm where all matter is gray. The title, as always, is important for its obvious contradiction of the image and yet its hinted revelation of what the painting is about.

Almost always discussed and thought of in terms of color, American painting after 1948 has known a tremendous revival of monochrome painting. In the wake of the Abstract Expressionists and their New York School colleagues, whose important use of the "black-and-white" mode is well known (and a subject in itself which could not be included in the scope of this exhibition), artists like Jasper Johns, Rauschenberg, and Warhol found their own purposes for monochrome. Even a "post-painterly" abstract painter like Stella was better able to fulfill some of his ideas in gray grisaille than in color, because "it is impossible to program or structure color successfully in the same a priori sequential manner as light and dark"[10] (cf. no. 108, Walker Art Center, Minneapolis).

Gray in Jasper John's paintings seems to signify a withdrawal from the stance of personal involvement, of risk-taking, associated with his brushy Abstract-Expressionist handling. This deliberate neutralization, even pseudo-mechanization of that manner is not, finally, a put-down; rather, in retrospect, one can see it as feelingly conservative of Abstract-Expressionist handling in the context of his radically different problem formulation. Were it

22

not so, his ironies would fail, because without really caring he could not arrive at those beauties of facture which lure us and then convince us that we have entered felt rather than fabricated ambiguities. Johns does not require his paintings to be abstract or not to be, which is to say that he means for us to know that he regards such an issue as passed. As to their sense, they have the sense fitting to a revery; but considering what he muses on, they may be called logical reveries. *Voice* (no. 106, D. and J. de Menil Collection) is a painting that contains that word, the signifier that signifies the primal instrument of all signification. It lies at the terminus of, and is partially obliterated by, an actual, paint-dragging sweep through the wet surface in the form of an arc, ostensibly made with a stick that remains in the work affixed flat against the surface at the point of its arrest. This in itself is a characteristic Johnsian device. But here, that signifier in the shadow of such a threat has a particular poignance. Painting, the art as we know it, is a remote consequence of the power of vocal articulation, without which there is no language, no writing, no history of ideas. Seeing the word VOICE in the painting brings home in a personal reaction the immediacy and precedence in our own concerns of that power and heightens the distance of the puzzlingly diffident context from which it is presented. And that diffidence is embodied by the sweeping stick which would wipe out the signifier of that which makes the chain of the painting's existence possible.

The gray of the printed newssheet and the coarse tabloid photograph is a metaphor in XXth-century painting for disposable life as well as disposable goods. It is the idiom of Picasso's *Guernica*; it appears pervasively in transfer form in Rauschenberg's work, and as a ground against which Johns plays his paint in *White Flag*. One of Andy Warhol's early moves (1961-62) was to do some straight paintings of tabloid cover sheets, the headlines most predictive of his direction being EDDIE FISHER BREAKS DOWN and 129 DIE IN JET, which hold up mirrors in a Brechtian-realist way to society's avid sentimentality and equally avid interest in the horrific, which are two sides of the same coin. In his subsequent silkscreened-photograph manner, the *Elvis* series (no. 112, Tom and Dana Benenson) is unique as a fusion of these polarities, the image of a ''sweet boy'' singer togged out and playing as a Western movie ''killer,'' and for no better reason than a Hollywood prescriptive career ladder. Stationed against a dull silvery background, the black screen-printed Elvis, putting on a tough-guy stance but retaining his soft good looks and a dandy's way of arranging his clothes, is a grim and haunting travesty.

That most of our visual information comes in black and white bears on our understanding of Chuck Close's work (see plate, p. 163). His huge renditions of small photographs deal mainly with the transmission of information from

23

one medium to another, from a small scale to a gigantic one. In his case, gray is used as a color—not one that conveys emotions or feelings (his pictures in color do not either), but one that exists before the artist's own choice and which is nothing but a carrier of his information. His aim is quite different from that of the XIXth-century "photographic academicians," whose use of monochrome was a literal and rather naïve translation of a newly invented medium. The same naïveté and almost primitive qualities can be found in the work of John Baeder (cf. no. 115, Mr. and Mrs. Judd Maze), whose paintings are, except for their dimensions, nostalgic renditions of 1940s postcards.

It would be tempting to say that, in his desire not to commit himself to a world of colors, the contemporary artist shares with the medieval one a common attitude. In both cases the monochrome is a means of affirming specificity of painting. The Middle Ages, humble and religious, saw in it a way to express the position of man's creation in a universe completed by God. As for the modern artist, working in a world which he has made his own, the gray monochrome enables him to differentiate his work from its environment, the artist's other paintings, or their "subjects." It has proven to be as rich in possibilities as a "modern" mode as it has in traditional uses over the centuries.

—J. Patrice Marandel

1. Max Kozloff, "The Many Colorations of Black and White," *Artforum* 11, no. 8 (Feb. 1964) p. 22.

2. Molly Teasdale Smith, "The Use of Grisaille as Lenten Observance," *Marsyas* 8 (1957-59) pp. 43-54.

3. Quoted with Professor Bober's kind permission from an unpublished document dated May 8, 1971.

4. *Ibid.*

5. *Introduction to Masters of the Loaded Brush: Oil Sketches from Rubens to Tiepolo,* an exhibition organized by the Department of Art History and Archaeology of Columbia University at M. Knoedler and Company, New York, April 1967, xviii.

6. E. Haverkamp-Begemann, "The Sketch," in *Painterly Painting*, Art News Annual XXXVII, 1971, pp. 57-74.

7. *Journal de Eugène Delacroix,* vol. 3 (Paris: Librairie Plon, 1932), p. 391.

8. Fairfield Porter, *Thomas Eakins* (New York: George Braziller, Inc., 1959), p. 27.

9. Klaus Berger, *Odilon Redon*, trans. by Michael Bullock (New York: McGraw-Hill, 1965), p. 14.

10. William S. Rubin, *Frank Stella* (New York: The Museum of Modern Art, 1970), p. 78.

Catalogue

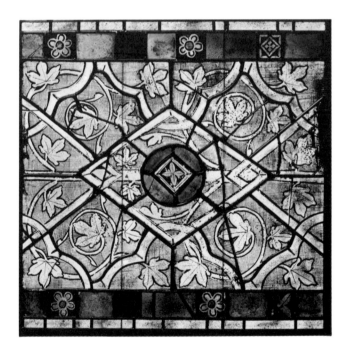

NOTE: The attributions in the captions are those given by the lenders. In all measurements height precedes width.

2 overleaf FRENCH, XIIITH CENTURY. *Decorative panel*, ca. 1260. Stained glass. 23 1/2 × 23 1/8 in (59.7 × 58.7 cm). The Metropolitan Museum of Art: The Cloisters Collection.
 Thought to be from the Château of Rouen (now destroyed).

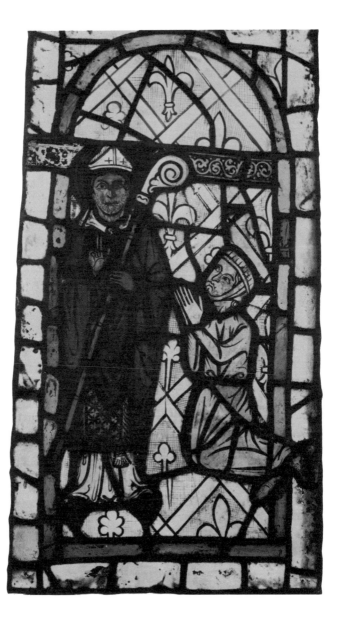

1 FRENCH, FIRST HALF OF THE XIIITH CENTURY. *A Holy Bishop and a Lady Donor*.
Stained glass. 25 1/4 × 13 in (64 × 33 cm). Jean Lafond, hon. F.S.A., Paris.
 This is one of the earliest known examples bringing together grisaille and colored glass. The figures stand out against a ground of monochrome lozenges containing fleurs-de-lys and flowers.

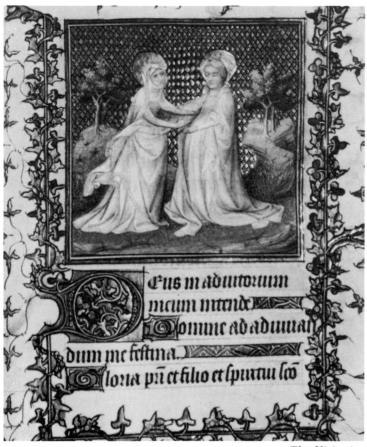

The Visitation

3 MASTER OF 1402 (French, active ca. 1400). *Book of Hours,* ca. 1400. Manuscript on vellum, four fascicles bound in blue morocco. 7 1/8 × 5 1/8 in (18.2 × 13 cm). Mark Lansburgh, Colorado Springs, Colorado.

Harry Bober of the New York University Institute of Fine Arts attributes this manuscript painting to the Master of 1402 (his analysis – in abbreviated form – was first published in the catalogue for a sale of May 1961 by Lathrop C. Harper, Inc., New York [No. 13, Item 1]). However, Millard Meiss, of the Institute of Advanced

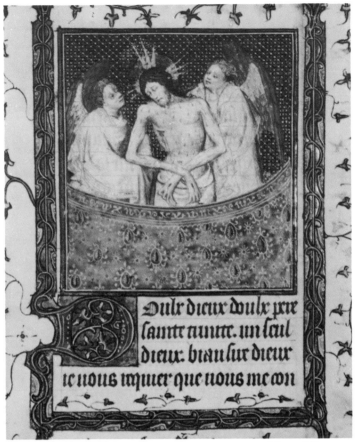

Man of Sorrows

Study, Princeton, attributes it to the Master of the Coronation (see French Painting in the Time of Jean de Berry: The Boucicaut Master [*London: Phaidon Press, 1968*], *illus. 464 – Man of Sorrows). The illustrations represent two of the quasi-grisaille miniatures of a total of seven in this style (another seven being in full polychrome). The figures under consideration are in virtual monochrome, i.e., opaque whites and delicately colored tints.*

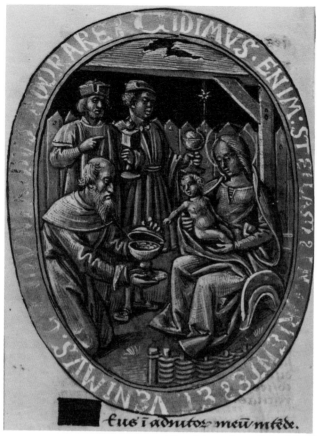

The Adoration of the Magi.

4 FRENCH, XVITH CENTURY. *Hours,* ca. 1510. Latin manuscript on vellum with calendar and final prayers in French. Yale MS 108. 5 5/8 × 3 7/16 in (14.3 × 8.7 cm). 64 folios including 16 miniatures in black and gray with a gold band framing each scene. Bâtarde script. Initials in gray, text in black and red. Bound in brown morocco tooled in gilt, with inside dentelles and edges gilt; silver clasps. The Beinecke Rare Book and Manuscript Library, Yale University.

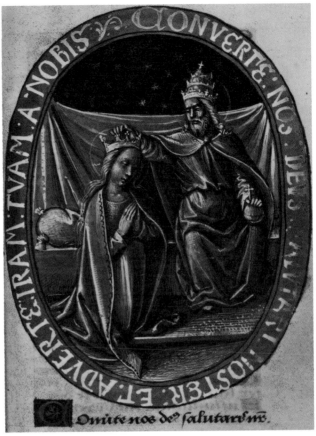

Coronation of the Virgin.

The early XVIth century saw the sudden expansion of printed books of hours. Artists who became fascinated by the potential of black-ink woodcuts made great use of them in wide margins filled with religious scenes and fabulous animals. The beauty of these black-and-white woodcuts was a real challenge to the illuminators, who were still painting by hand. It is possible that this manuscript, which is painted entirely in blacks and grays, is a response to that challenge.[1] In any case it represents a stunning departure from the ordinary.

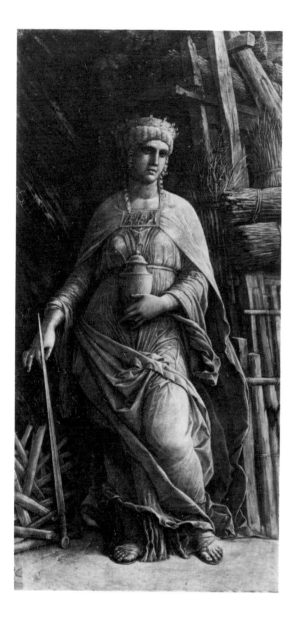

5, 6: Mantegna was an enthusiastic admirer of antiquity, which he studied directly from fragments and through the work of Donatello. As a Paduan artist, he may have been influenced by the bronze technique which flourished in the city, and which could have developed his taste for sharp forms and occasional monochromes. The scrupulous observation of nature in these paintings and the classical elegance of the figures are characteristic of Mantegna's style.[2]

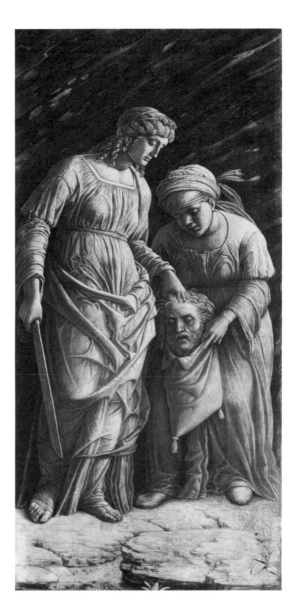

5 opposite ANDREA MANTEGNA (Italian, 1431-1506). *Dido,* ca. 1480. Tempera on linen. 25 3/4 × 12 1/4 in (65.4 × 31.1 cm). The Montreal Museum of Fine Arts: purchased 1920, Tempest Fund.

6 above ANDREA MANTEGNA. *Judith,* ca. 1480. Tempera on linen. 25 3/4 × 12 5/16 in (65.4 × 31.3 cm). The Montreal Museum of Fine Arts: purchased 1920, Tempest Fund.

7 FRENCH, XVITH CENTURY, BURGUNDIAN SCHOOL. *St. George and the Dragon*. Oil on panel. 27 × 29 15/16 in (68.6 × 76 cm). Musée du Louvre, Paris.

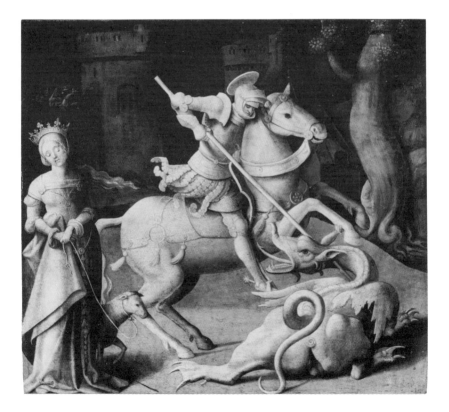

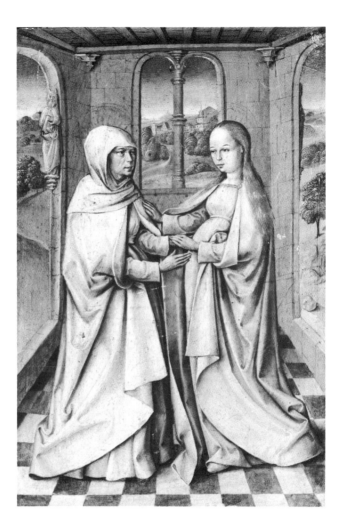

8 FLEMISH, FIRST HALF OF THE XVTH CENTURY. *The Visitation.* Oil on panel.
14 1/4 × 9 in (36.2 × 22.9 cm). The Denver Art Museum.

9 left GERMAN, XVITH CENTURY. *St. Roch*. Tempera on wood panel. 49 1/4 × 12 in (125 × 30.5 cm). The Art Museum, Princeton University.
 Wing of a polyptych: polychrome figure of a carpenter, recto.

10 right GERMAN, XVITH CENTURY. *St. Christopher*. Tempera on wood panel. 49 1/4 × 12 in (125 × 30.5 cm). The Art Museum, Princeton University.
 Wing of a polyptych: polychrome figure of a mason, recto.

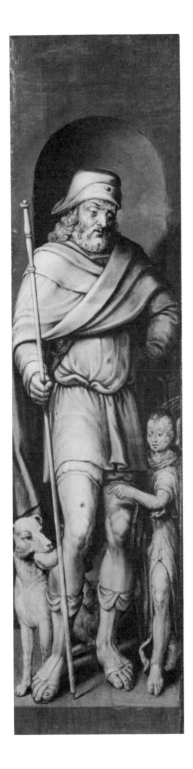
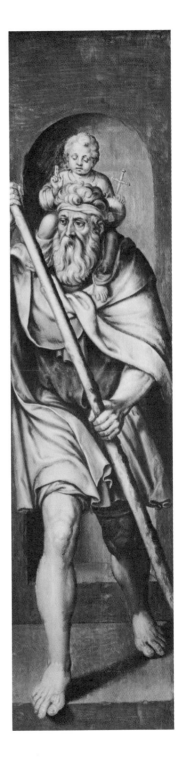

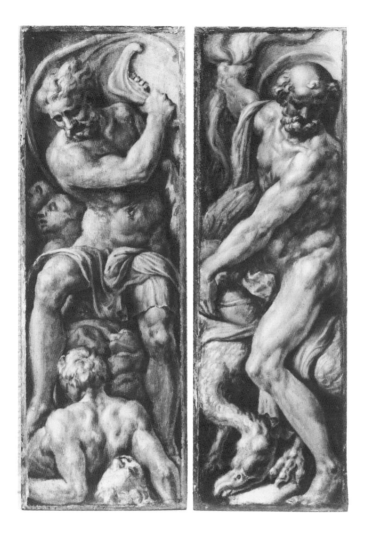

11 above MAARTEN VAN HEEMSKERCK (Dutch, 1498-1574). *Samson Slaying the Philistines; Jupiter*, ca. 1535. Oil on oak panel. 18 1/2 × 6 1/4 in (47 × 15.9 cm) each panel. Allen Memorial Art Museum, Oberlin College.

12 opposite MAARTEN VAN HEEMSKERCK. *Strong Men*. Four panels, in one frame: *Saturn Devouring a Child; Hercules Slaying the Hydra; Hercules Lifting Antaeus; Hercules Erecting the Columns of Calpe and Abyla*. Oil on panel. 21 11/16 × 28 5/8 in (55.1 × 72.7 cm) [with frame]. Yale University Art Gallery: gift of Chester D. Tripp, B.A. 1903.

11,12: When he was already thirty-four and working in Haarlem in a style influenced by Jan van Scorel, Heemskerck traveled to Italy, as was the custom for artists. He spent three years there drawing his famous views of Rome and making studies after the Antique and Michelangelo. The influence which the master had on Heemskerck's later work is evident in the two groups of panels seen here.

In the late XVth century a tradition of collaboration between artists and furniture-makers had developed in Italy. Although the decorations used on furniture of this period consisted for the most part in carving or inlay work, it was not unusual for prominent artists to paint decorations as well.[3] There are XVIth-century examples of large cabinets which incorporate panels painted in brown monochrome, supposedly an imitation of bronze sculpture.[4] Considering the size and the subject matter of the Heemskerck panels shown here, it is possible that they were meant to decorate such a cabinet.

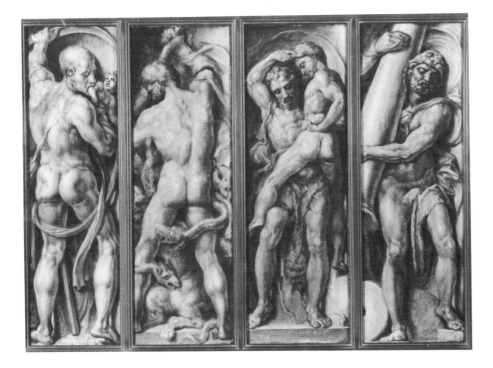

13 ATTRIBUTED TO GIULIO ROMANO (Italian, 1499-1546). *L'Abondance*. Oil on panel.
15 × 12 1/4 in (38 × 31 cm). Musée du Louvre, Paris.

*The grisaille L'Abondance represents a female figure in a niche; she is nude under
a transparent drapery, and she holds a cornucopia. Below the figure is an inscription:* RAPHAEL URBINAS.

*The painting is not by Raphael's hand, but it has practically the same dimensions
as a Raphael that is also in the Louvre. This coincidence and the strange inscription
have been something of an enigma.*

*The Raphael with which L'Abondance is associated represents the Virgin and
Child, St. Elizabeth, and St. John. It has come to be known as* La petite Sainte Famille
(Louvre inv. 605). In the Gazette des Beaux-Arts *of 1881, Paliard has argued that the
grisaille L'Abondance could be the protective covering panel for* La petite Sainte
Famille.[5]

Such a covering panel is mentioned by André Félibien in his Entretiens sur les vies
et sur les ouvrages des plus excellents peintres anciens et modernes, *published in
successive issues from 1668 to 1688. Félibien writes that the Raphael painting is
"covered with a little painted panel decorated in a manner as skillful as it is
pleasant"* (d'une manière aussi sçavante qu'agréable).[6] *Unfortunately no description
or dimensions are given, nor is there any mention of grisaille. Yet the "skillful and
pleasant manner" could well apply to* L'Abondance.

*A covering panel is again mentioned in an inventory of the collection of Louis XIV,
dated 1683 and signed by Lebrun. A Raphael (no. 118) which corresponds precisely
to* La petite Sainte Famille *in its description is said to have "a sliding panel (*une
coulisse*) painted in grisaille."[7] The dimensions given there (14* pouces *[37.8 cm] in
height and 11* pouces *[29.7 cm] in width) are near to those of* L'Abondance, *with the
differences of 0.2 cm in height and 1.3 cm in width.*

*The Lebrun inventory gives still more information: the sliding panel in grisaille is
"by the same hand" as the painting behind it. It is thus considered to be by Raphael.*

*"The small Virgin by Raphael" and "the figure in grisaille by Raphael" are
mentioned again in a 1695 inventory,* Mémoire des tableaux qui sont exposés dans les
appartements du château de Versailles, *but this time the two are not associated, and
they hang in two different places.*[8]

*The name of Raphael in connection with our painting is mentioned for the last time
by Louis-Jacques Du Rameau in 1784, in the* Inventaire des tableaux du Cabinet du
Roi: *"A female figure holding a cornucopia, by Raphael."*[9] *The description is
precise: it is* L'Abondance. *The name of Raphael might have been advanced because
it is painted on the panel. One cannot help wondering if the previous attributions of
the grisaille to Raphael might not simply have been made on the strength of the
inscription, and thus have referred to* L'Abondance.

In 1709, Nicolas Bailly in his Inventaire des tableaux du roi[10] *mentions (p. 34) in
the Petite Galerie du Roy a "painting representing a figure in grisaille of 9 to 10*
pouces *having 13* pouces *[35.1 cm] in height and 11* pouces *[29.7 cm] in width, in its
gilded frame." He attributes the painting to Giulio Romano.*

In 1752, Lépicié, in the first volume of his Catalogue raisonné des tableaux du roi[11]
*mentions a grisaille which he calls "a female figure in a niche as the emblem of
Abundance." The measurements he gives are 14* pouces *(37.8 cm) in height by 11 1/2*
pouces *(31 cm) in width. They are the measurements given by Lebrun for the Raphael
painting and its sliding cover, with only a discrepancy of 1.3 cm in the width. Lépicié*

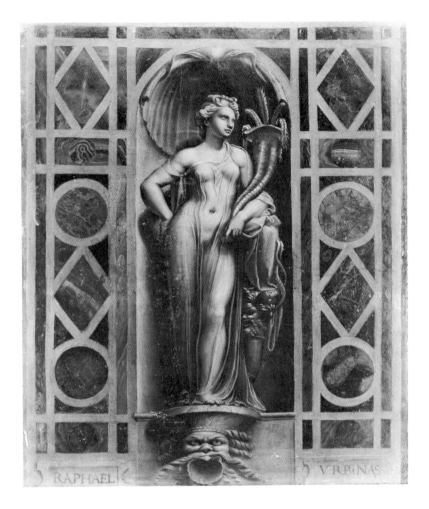

RAPHAEL VRBINAS

adds, "Though this painting [the grisaille] is attributed to Giulio Romano, one reads below the figure: Raphael Urbinas."

Later catalogues and inventories throw no further light on the possible connection of L'Abondance with La petite Sainte Famille. Today, the association of a quasi-nude figure with a religious painting looks strange. It would not have seemed so during the Italian Renaissance, for at that time nudity meant dissociation from worldliness and had a divine connotation. Cardinal de Boissy, who is supposed to have commissioned the Raphael, might have chosen the subject of the covering panel himself as his emblem.

The fact that there was a panel in grisaille covering La petite Sainte Famille (Lebrun), that it was painted in a "skillful and pleasant manner" (Félibien), that the dimensions are nearly the same as those of L'Abondance (Lebrun)– all these factors strongly suggest that this grisaille is the covering panel for the Raphael.

Paliard argues further that a painted cover to an authentic Raphael could well have been done in the studio of the master by one of his assistants, and that the inscription RAPHAEL URBINAS would have referred, not to the artist of the grisaille panel, but to that of the painting underneath, like the title of a book on its binding. The inscription is awkwardly written. The letters are irregular and not evenly spaced. Obviously they are not by the same hand as the painting. The inscription might have been added later, not with the belief that the panel was by Raphael, but with the knowledge of what it was covering. The confusion arose only when panel and painting were separated.

One stumbling block remains: the signature of Lebrun on the inventory of 1683 which says that the sliding cover is "by the same hand" as the painting underneath. It is inconceivable that Lebrun, even at the age of sixty-four, would have mistaken the hand of an assistant for the hand of the master. Could he have signed without carefully reading what an aide had written?

Finally, how could the grisaille sliding panel which protected the Raphael have disappeared without leaving a trace? Mention of it ceased as soon as the name of Giulio Romano appeared in connection with a grisaille panel of the same size.

14 GIULIO ROMANO . *Triumph of Silenus*. Oil on canvas. 10 5/8 × 20 1/2 in (27 × 52.1 cm). Portland Art Museum, Portland, Oregon.

Although this painting has traditionally been attributed to Giulio Romano, its authorship was reconsidered in 1955 by Frederico Zeri. The following is an excerpt from an article in Paragone *in which he explains his theory that it was painted by the young Rubens, working in Italy.*

"It is surprising that this fine painting still carries the name of Giulio Romano, to whom it was attributed while in the Earl of Pembroke's collection at Wilton House. Carrying this same attribution, it passed to Christie's of London in the Pembroke Sale of June 22, 1951. . . . The information that the picture had been in the collection of Charles I (the catalogue of 1639, in fact, mentions it as hanging in the Queen's bedchamber) ought to have provided final confirmation of those indications, apparent at first glance of an early XVIIth-century origin. If indeed characteristics of Giulio Romano can be discerned in certain passages–the accentuation of the features of the fauns, for instance–nevertheless the classical high relief is seen with eyes from which every trace of erudite pedantry has disappeared. Giulio Romano combined pedantry with an emphatic explosion of sustained, enlarged, abnormal rhythms,

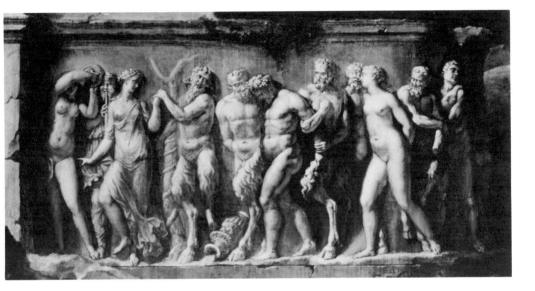

which occur not for figurative ends but for their architectonic and decorative values in the surroundings for which the work was executed. *But here there is a fine sensitivity, almost an affection, for the ancient slab of marble. Its cracks and chips, its patina are described not with the archaeologist's minute regard for detail, or with the bombast and rhetoric of 'the Rome that has departed,' but in a way that reflects a rediscovery of its historic significance – a consideration which by itself should exclude the possibility of a date within the first half of the XVIth century. The light etches the volumes and recesses lovingly, with a superb knowledge of transitions and modulations, accenting the rhythm of the bacchic procession. The procession is conceived with all the cleverness and astuteness of the Mannerist vocabulary, but here, too, with what a prodigious leap the limits of Mannerism are overcome. . . . The rhetorical rhythms of Trajanic and Severan sculpture which had so fascinated the early Mannerists and Raphael's students here dissolve into a miraculous resurrection of the Hellenism of Pergamon, Alexandria, and Halicarnassus. It goes without saying that such passages in this monochrome, which can be dated about 1606 or a little later, find echoes in other works by Rubens dating from about the same time. Thus the first figure at the left appears – in a somewhat different form, to be sure – in* the Judgment of Paris *at the Prado, dated by Burchard as 1604-1605. And in the drunken Silenus, who advances at the center, supported by two satyrs, one can see the forerunner of similar passages in later, more celebrated 'Bacchanals.' ''* [12]

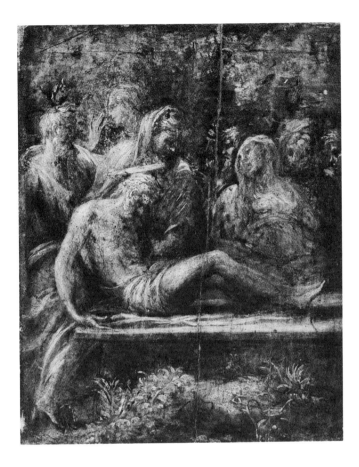

15 Francesco Mazzuoli, Il Parmigianino (Italian, 1503-40). *The Entombment.* Oil
on panel. 9 3/4 × 7 5/8 in (24.8 × 19.4 cm). Suida Manning Collection, New York.

One of a group of 10 known sketches, most of which are drawings of various
details, made preparatory to an engraving which was executed by Parmigianino
himself.[13] *Here the artist seems to have chosen the medium of oil to rough out the*
relationships of the figures and especially the disposition of light and dark areas.

16 FRANS POURBUS I (Flemish, 1545-81). *The Last Supper*. Oil on paper mounted on canvas. 15 3/4 × 22 in (40 × 55.9 cm). Musée des Beaux-Arts de Caen.

Jacques Foucart has studied this painting and considers it a work of great importance and exceptional rarity. Its signature, undoubtedly authentic, is corroborated by stylistic evidence: the painting shows the same elegant and supple Italianism that appears in the triptych of St. George in the Musée de Dunkerque. The Venetian influences– Veronese's ease of manner, and disposition of forms like Tintoretto– are especially apparent. There is a striking similarity between this Christ and the one in The Resurrection of Lazarus, *the exterior wing of the famous triptych in the cathedral of Ghent, signed and dated 1573, in which we find the same face, the same gestures, and identical drapery.*

Frans Pourbus I, the son of Pieter Pourbus and the father of the well-known portraitist of Henri IV and Marie de Medici, died young, at thirty-six, and left little work except for portraits. Not until now was any modello *of this sort known to exist. The gap thus filled is important in light of the interest in such grisailles shown by Northern artists since Aertsen and Brueghel (*Death of the Virgin, Upton House, Egdeville*), up through Floris and Otto Vaenius to the Franckens, Rubens, and Van Dyck. Hence the importance of* The Last Supper *in the history of Northern grisaille and, in a more general sense, in the development of the use of grisaille by the Italians from Parmigianino and Veronese to Francesco Vanni, if we consider only the XVIth century.*

It is probable that the modello *was destined to be engraved, as was the Brueghel grisaille. This cannot, however, be proved definitely, since no engraving of* The Last Supper *by or after Frans Pourbus I is known.*

As regards the presence of the signature, we may deduce only that, for the painter as for the client (to whose charge fell the making of the engraving), this sketch seemed finished and sufficient unto itself, as was Brueghel's monochrome sketch of the Death of the Virgin. *There is certainly every reason to believe that grisailles of this period were considered to be finished paintings; the technique was no longer used simply for preparatory sketches for larger compositions, nor was it relegated to secondary parts such as the exterior faces of altarpieces. The presence of an* invenit *not followed by a* fecit *or a* pictor *– even if it seems exceptional in the case of Pourbus – by no means constitutes a unique case in the paintings of the period; it is encountered many times in the paintings of Heemskerck, for example. Therefore the "Inv." following the signature does not imply that the composition would be engraved by a specialist, as is sometimes the case with Van Dyck or Rubens, who worked at a time when the engraving of reproductions after paintings posed far greater problems than in the time of Frans Pourbus I.* (From Jacques Foucart, "Peintures des écoles du Nord du XVI ᵉ siècle," *Revue du Louvre*, No. 4-5 [1968], pp. 179-86.)

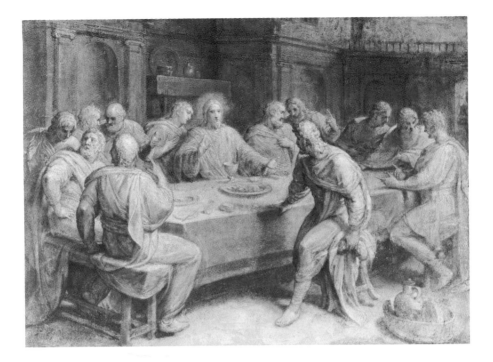

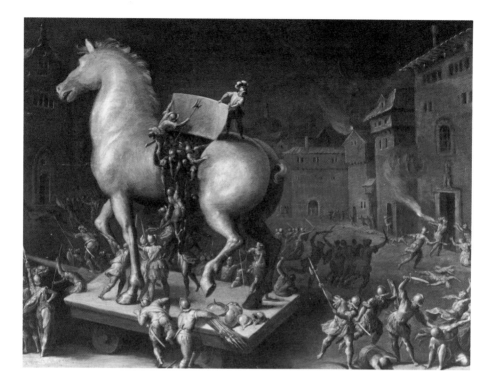

17 FLEMISH, XVITH CENTURY, formerly attributed to Gillis van Valckenborch. *The Trojan Horse*. Oil on panel. 19 13/16 × 26 in (50 × 66 cm). Wadsworth Atheneum, Hartford: the Ella Gallup Sumner and Mary Catlin Sumner Collection.

Charles Sterling notes: "I see no reason to recognize the hand of Gillis van Valckenborch in The Trojan Horse, *a seductive Mannerist painting, perhaps by a Flemish artist but surely in the Tuscan tradition. Valckenborch himself had a more 'polished' manner. . . . Elongated figures and dense crowds are typical of his work: they betray a relationship with the German Mannerist painters, for example, Spranger. Mannerism drew from the tradition of Parmigianino and Tintoretto–their poetics of taut grace and visionary lighting. The painter of* The Trojan Horse, *however, is a descendant of the Tuscans, because (1) he orders his composition like a ballet, and (2) he scatters rhythmic passages throughout his painting, as did Antoine Caron in France. Having never seen the painting I cannot give an attribution, and recommend instead that it be designated 'Anonymous XVIth Century.' "* [14]

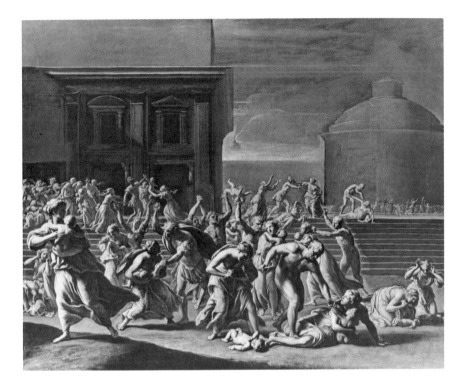

18 FRENCH, XVIITH CENTURY. *The Massacre of the Innocents*. Oil on canvas.
24 × 29 in (61 × 73.7 cm). Musée des Beaux-Arts de Rouen.
 For stylistic reasons, thought to be by an artist working in the manner of Poussin,
possibly Jacques Stella.

<div align="right">—J.P.M.</div>

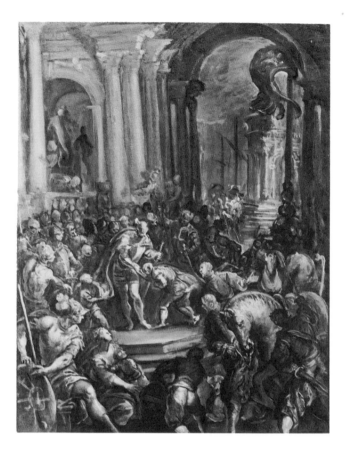

19 ANDREA VICENTINO (Italian, XVIth Century). *Alexius Comnenus Appearing before the Doge*, after 1577. Oil on linen. 35 3/4 × 27 in (90.8 × 68.5 cm). Minneapolis Institute of Arts: the John R. Van Derlip Fund.

A modello *for the large painting in the Sala del Maggior Consiglio of the Doges' Palace in Venice, this work depicts the youthful Alexius IV Comnenus begging the Doge to divert the forces of the Fourth Crusade against Constantinople in order to restore his deposed father to the Byzantine throne. This was accomplished in 1203, but at great cost: Constantinople fell under Crusader domination, and Alexius, who ruled with his father, became their puppet, only to be killed the following year in a*

popular revolt. The independence of his successor provoked the tragic sack of Constantinople in 1204.

In the view of Terence Mullaly the modello, *one of the few paintings by Vicentino to have left Venice, "is crucial for an appreciation of Andrea Vicentino. . . . The finished picture, despite the excellence of its execution, is unoriginal in design, confused, and overladen with detail. A comparison of it and the* modello *reveals that no major alteration has been made and many of the main figures are virtually identical. Yet the* modello *is much more effective. . . . The flickering highlights, executed with brushwork of telling bravura, contribute towards creating an impression of tension. It is in his few surviving works like this that one prefers to recall Andrea Vicentino."* [15]

20 GILLIS VAN VALCKENBORCH (Flemish, 1570-1622). *Judith Showing the Head of Holofernes to the Populace.* Oil on wood. 11 1/2 × 16 1/4 in (29.2 × 41.3 cm). D. and J. de Menil Collection, Houston.

This painting has been attributed by Professor Charles Sterling to Gillis van Valckenborch through a comparison with the signed Defeat of Sennacherib, *in the Herzog-Anton-Ulrich Museum at Brunswick.* [16]

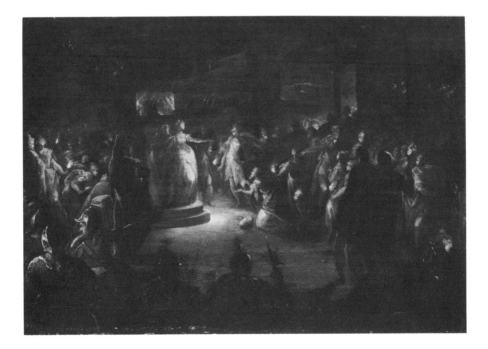

21 François de Nome, previously known as Monsu Desiderio (French, active 1st half of XVIIth Century). *Architectural Ruins by Night.*[17] Oil on canvas. 40 3/4 × 60 3/4 in (103.5 × 154.3 cm). Private collection, U.S.A.

An article by Louis Réau in 1935[18] and two exhibitions in 1950[19] attracted attention to Monsu Desiderio, an enigmatic painter who had been active in Naples during the first part of the XVIIth century, and who had fallen into oblivion. His strange paintings have characteristic features. They combine architectural elements without any regard to periods or styles. Buildings, often in ruins or collapsing, emerge as apparitions bathed in an eerie light. Statues and decorative motifs are shaped with thick blobs of paint which give them a slight relief, like Córdoba leather.

Several art historians besides Réau have examined the paintings and searched archives to solve the mystery of Monsu Desiderio. In a critical analysis of the documents thus discovered, Felix Sluys has convincingly argued that there were actually two painters whose works were ascribed to Monsu Desiderio. Both natives of Metz, born only two years apart, and both active in Naples at the same time, they were Didier Barra, known as Monsieur Désiré or "Monsu Desiderio," and François de Nome. Sluys has suggested that the painters shared a workshop and that, after their deaths, unsold paintings might have been disposed of as by "Monsu Desiderio." He further advances that they had collaborated on some canvases and had

52

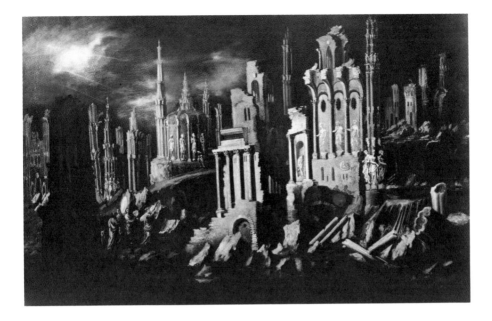

represented themselves in The Tower of Babel: *in the foreground, two men, obviously the architects, together hold a sketch of the tower, which they present to the king.*[20]

Of the two painters, the most interesting is the visionary, François de Nome. His name appeared for the first time when Professor R. Causa identified his signature, "francisco de nome," as a Gothic inscription on the base of a statue in Sodom and Gomorrah. *Causa found other variations: "D. Nome," "Did. Nome," "Fran.," all on the characteristically strange paintings hitherto attributed to Monsu Desiderio.*[21]

The archives of Naples yielded the following information: In 1613 a native of Metz, Lorraine, married the daughter of an obscure painter of banners in Naples. The groom's signature on the marriage act reads "François de Nome." When requested to give some information on himself, he declared that he was about twenty years old, that he had left his paternal home eleven years before, and that he went with a group to Rome, where he stayed eight years and "learnt the noble trade of painting."[22]

Sluys thinks that François de Nome, the nine-year-old runaway, was mentally disturbed; only as such could he have produced such disquieting paintings, full of unconscious symbolism.

22 PETER PAUL RUBENS (Flemish, 1577-1640). *The Road to Calvary*, ca. 1632. Oil, emulsion paint on wood. 23 1/8 × 17 in (58.7 × 43.2 cm). University Art Museum, Berkeley.

Julius Held has noted that this sketch is one of a number of works representing Rubens's development of this theme over a period of years, which culminated in 1636 in a large canvas of the same title (Brussels, Musée Royal des Beaux-Arts de Belgique). Nevertheless, he maintains that it "occupies a special place in this development, as it was not made for a painting but for an engraving–the well-known print by P. Pontius, dated 1632. This function–to serve as a model for an engraver– explains the features which distinguish this sketch from others in that series, and from the majority of Rubens sketches in general. Its largely monochrome tonality and its surprising exactness in regard to relatively small details are features that are normally not found in Rubens's oil sketches." Held adds immediately, however, that "it is not unique: there are several such grisaille sketches made for the purpose of being engraved.

"The proof for my claim that this sketch was from the beginning planned to serve for an engraving is very simple: most of the figures are rendered 'left-handed' in the sketch, which makes sense only if they were planned for reversion in print. The soldier in armor at the right pushes Christ with his lance, held in his left hand; the man who pulls Christ's hair swings his whip (a folded rope) in his left; the three men on horseback at the top of the composition hold their attributes (a rod or scepter, a musical instrument, and a flag) in their left hands.

"Contrary to F. Antal (who knew the composition only from the engraving, and who dated it in the years 1615-18), I agree with most modern scholars that the sketch was painted just prior to 1632, the date on the print. The unified movement of the entire scene, with every figure contributing to the upward sweep of the action, corresponds to the style of Rubens's later works rather than his earlier ones. I even believe that Rubens was aware of the fact that this irresistible motion would carry the eye of the beholder along its upward path more forcefully if read from lower left to upper right, as it appears in the engraving, inducing him to use in his sketch the opposite direction, from lower right to upper left. I should like to point out, however, that Rubens meant us to read the action not entirely in the main diagonal: you will see on closer study that the two horsemen at the upper left turn inward, towards the mountain, and that they are actually preceded by other figures, one of whom is seen carrying a ladder; the path of the whole procession hence describes a curve along and around the cliff with its gnarled tree at the right."[23]

The pink rays around the head of the Christ, unusual in a grisaille, reveal the authority of a master.

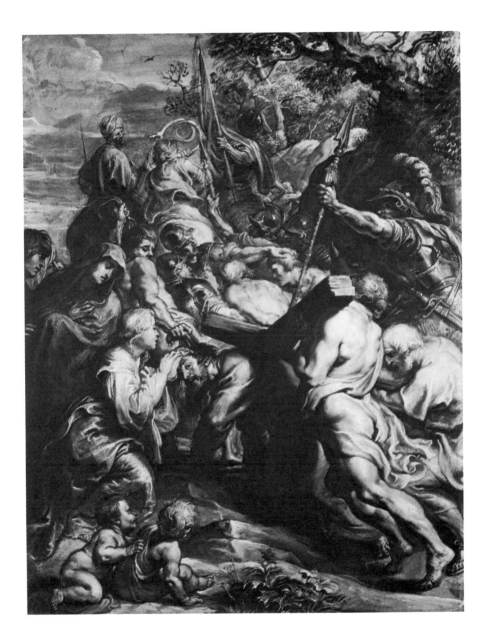

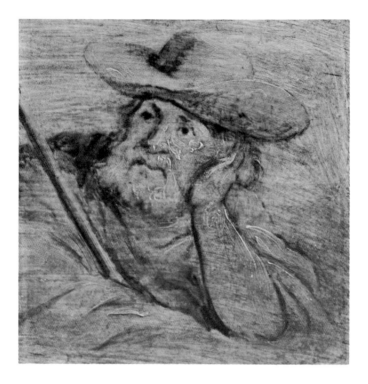

23 above Anthony van Dyck (Flemish, 1599-1641). *Head of an Old Man Wearing a Hat and Holding a Staff*. Oil on panel. 3 5/8 × 3 7/16 in (9.2 × 8.8 cm). Suida Manning Collection, New York.

24 opposite Jean de Saint-Igny (French, 1600-49). *Air,* ca. 1636. Oil on panel. 13 3/8 × 10 1/4 in (34 × 26 cm). Musée des Beaux-Arts de Rouen.
 Saint-Igny was apprenticed to a painter in Rouen in 1614. Around 1625-30 he went to Paris, where it is believed he must have known Georges Lallemand and other Mannerist painters of the period. He returned to Rouen in 1631 and became a member of the Confrérie de Saint-Luc, and in 1635 was named Master of the

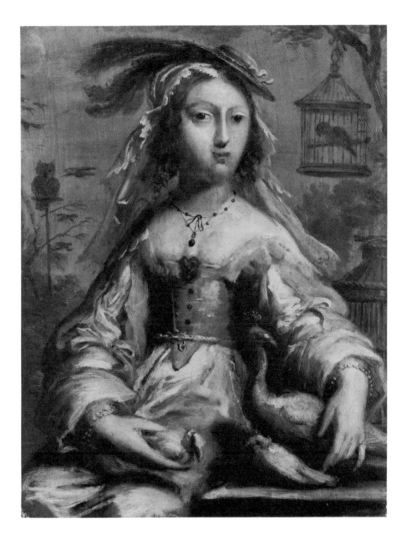

Confrérie. Records of payments made to him prove he was alive as late as 1647.[24]

According to Jules Hédou, who wrote on Saint-Igny, and who willed this panel to Rouen, it bore the following inscription: "les Ele. Il L'Air." Hédou dated it ca. 1636, a date which is corroborated by the costume. Another panel of identical size is in a private Parisian collection. It may depict La Terre *(Earth), and be part of the same series as* L'Air.

This small grisaille panel presents affinities with engravings by Rabel, Isaac Briot, Leblond, and Abraham Bosse. Saint-Igny was essentially an engraver or designer of costumes; the Musée de Rouen possesses an unpublished series of his costume designs.[25]

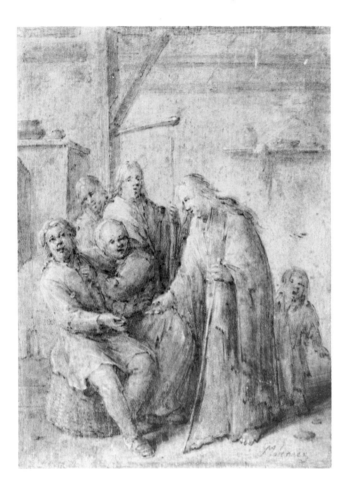

25 JAN MIENSE MOLENAER (Dutch, 1610-68). *Alms*. Oil on panel. 9 7/8 × 7 1/8 in (25 × 18.2 cm). Musées de la Ville de Bourges.

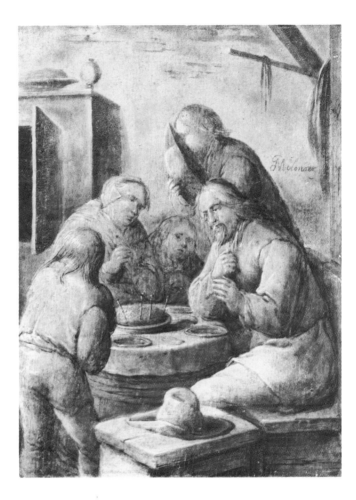

26 JAN MIENSE MOLENAER. *Grace*. Oil on panel. 9 7/8 × 7 1/8 in (25 × 18.2 cm).
Musées de la Ville de Bourges.

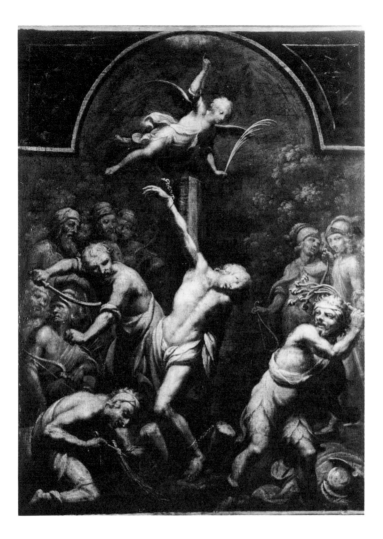

27 above QUENTIN VARIN (French, 1580-1645). *The Flagellation.* Oil on canvas. 33 1/16 × 24 3/4 in (84 × 63 cm). Musée Départemental de l'Oise, Beauvais.

28 opposite DANIEL SEGHERS (Flemish, 1570-1661). *A Garland of Flowers with the Education of the Virgin.* Oil on canvas. 47 7/16 × 37 in (120.5 × 94 cm). Worcester Art Museum: Eliza S. Paine Fund, in memory of William R. and Frances T.C. Paine.

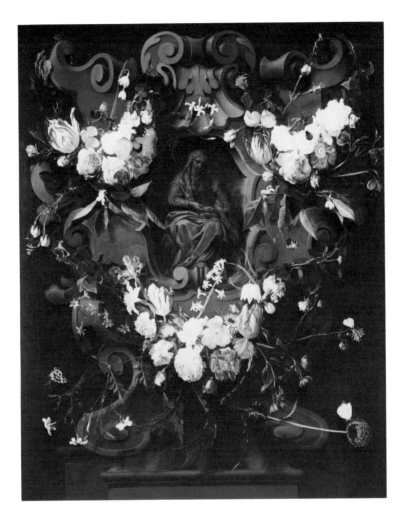

Seghers, a renowned painter of flowers who studied painting under Velvet Breughel, spent most of his life in Antwerp as a lay brother in the Jesuit order. He often combined his flower compositions with architectural motifs in grisaille. The figures in the niches were done by other painters–in this case, probably Erasmus Quellin II.

29 CLAUDE GUY HALLÉ (French, 1652-1736). *Joseph Explaining the Dreams*, ca. 1730. Oil on canvas. 13 3/16 × 10 1/2 in (34 × 26.7 cm). Private collection.
In spite of indications on the back of the painting that it represents Joseph Explaining the Dreams, *the subject could be* Christ Visiting Peter and Paul in Jail.
—J.P.M.

A nephew of Sebastiano Ricci, with whom he collaborated in Venice, Marco showed a real interest in landscape from his earliest works. Between 1708 and 1715 he went twice to England where he executed numerous seascapes and battle scenes.

It is probable that Ricci went to Rome in 1719, which would explain the appearance of Antique ruins in his landscapes. These three works from Raleigh could be assigned to this period. They illustrate Ricci's new search for light effects, effects which are as subtly rendered in the grisaille technique as in the etchings he undertook at the same time.

—C.R.

30 MARCO RICCI (Italian, 1676-1729). *Girl at Well with Roman Ruins.* Oil on cardboard. 8 1/2 × 6 3/4 in (21.6 × 17.2 cm). The North Carolina Museum of Art, Raleigh: gift of Oscar and Jan Klein, New York.

31 MARCO RICCI. *Shepherd and Shepherdess near Roman Ruins.* Oil on cardboard.
8 1/2 × 6 3/4 in (21.6 × 17.2 cm). The North Carolina Museum of Art, Raleigh: gift
of Oscar and Jan Klein, New York.

32 MARCO RICCI. *Girl on a Donkey with a Young Man*. Oil on cardboard. 6 × 5 in (15.2 × 12.7 cm). The North Carolina Museum of Art, Raleigh: gift of Oscar and Jan Klein, New York.

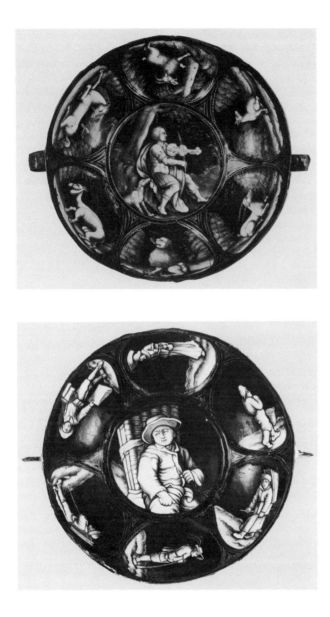

33 above ATTRIBUTED TO PIERRE II NOUAILHER (French, ca. 1665-1717). *Bowl with Orpheus Soothing the Wild Beasts in grisaille*. Enamel on copper. 1 1/2 in (3.9 cm) high; 5 3/4 in (14.6 cm) diameter. Menil Foundation, Houston.

34 below JEAN II LIMOUSIN (French, ca. 1561-1646). *Bowl with representation of the Trades in grisaille*, ca. 1635. Enamel on copper. 1 7/8 in (4.8 cm) high; 5 3/4 in (14.6 cm) diameter. Menil Foundation, Houston.

35 FRENCH, XVIIITH CENTURY. *Vertumnus and Pomona*. Oil on canvas. 45 11/16 ×
61 13/16 in (116 × 157 cm). Musée des Arts Décoratifs, Paris.

*Pomona was a beautiful Roman nymph who loved her gardens and orchards. She
shunned the suitors who flocked around her until Vertumnus came to her disguised as
an old woman and, with an old woman's license, began to kiss her. Startled, she drew
back; he released her and sat down beneath an elm over which grew a vine heavy with
purple grapes. He said softly, ''How lovely the tree and vine are together, and how
different they would be apart, the tree useless and the vine on the ground, unable to
bear fruit. Are you not like such a vine, when you turn from all who desire you? You
try to stand alone. And yet there is one–listen to an old woman who loves you more
than you know–you would do well not to reject, Vertumnus. You are his first love, and
his last. And he too cares for the garden, and will work by your side.'' With this, he
dropped his disguise and stood before Pomona a radiant youth. She yielded to such
beauty joined to such eloquence, and henceforward her orchards had two
gardeners.*[26]

*During the exhibition it was noted that this painting is signed with Jacob de Wit's
signature at the lower right, identically as it appears in his* Allegory of the Treaty of
Aix-la-Chapelle *(cat. no. 47). The date following the signature is quite faint, but
probably is 1752.*

36 above FRENCH, XVIIITH CENTURY. *Rome*. Oil on canvas. 24 1/4 × 61 3/4 in (61.6 × 157 cm). Cooper-Hewitt Museum of Decorative Arts and Design, Smithsonian Institution.

37 below ITALIAN, XVIIITH CENTURY, ROMAN SCHOOL. *Allegorical Figures of Counsel, Splendor of Name, Nobility, Dignity, and Merit*. Oil on canvas. 12 1/2 × 29 1/4 in (31.8 × 74.3 cm). Fogg Art Museum, Harvard University: gift of the Ehrich Galleries.

John A. Pinto has placed this painting in the XVIIIth century through a comparison of the allegorical figures represented there with those in a late-XVIIth-century edition of Cesare Ripa's Iconologia, *an illustrated compendium of allegorical and symbolical material. The attributes and attitudes of each figure are strikingly similar to those of the illustrations in the 1669 edition of* Iconologia, *leading Pinto to conclude that Ripa's volume was the literary source for the artist of the* Allegorical Figures.[27]

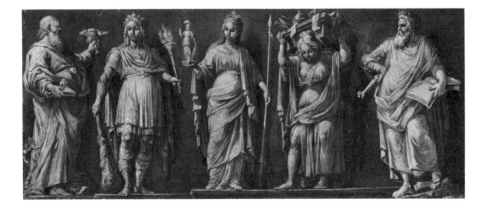

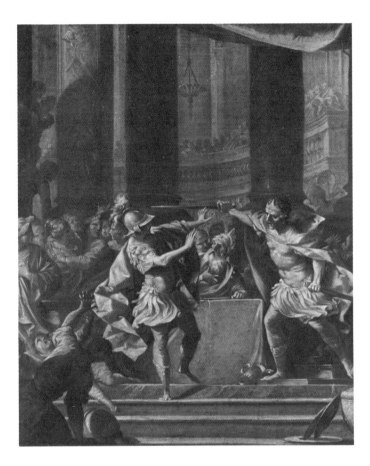

38 DONATO CRETI (Italian, 1671-1749). *Philip of Macedonia Checking the Anger of Alexander,* ca. 1705. Oil on canvas. 28 3/4 × 22 1/2 in (73 × 57.1 cm). Galerie Heim, Paris.

This is the first idea, dating probably from ca. 1705, for the painting in the National Gallery in Washington (Kress Collection). This grisaille study shows many differences from the final painting.[28]

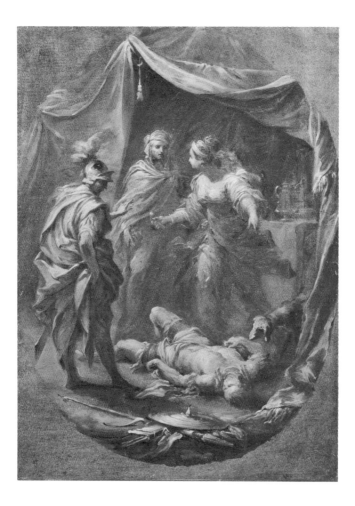

39 FRANCESCO MONTI (Italian, 1646-1712). *Jael and Sisera*. Oil on paper laid on canvas. 15 1/8 × 10 7/8 in (38.4 × 27.6 cm). The Museum of Fine Arts, Houston.

40 ADAM VAN SALM (Dutch, active ca. 1706-19). *A Harbor Scene*. Oil on panel.
17 3/4 × 24 3/4 in (45 × 63 cm). Menil Foundation, Houston.

This view has been identified by B.J.A. Renckens of the Rijksbureau voor Kunsthistoriche Documentatie as the estuary of the Maas at Rotterdam. A version with a similar composition has been published by J.B. van Overeem, director of the Maritime Museum Prins Hendrik in Rotterdam and an expert on Adam van Salm, in Rotterdams Jaarboekje *(1958), page 1-24.*[29]

41-43: In the early XVIIIth century, an enterprising Irish expatriate, Owen McSwiny, hit upon a money-making project whose merit was surpassed only by its timeliness. England had just gone through a great period in her history, rich in remarkable men and stirring events. McSwiny capitalized on the wealth of the ruling class, on their pride in these achievements, and on their esteem for Italian artists by commissioning twenty-four large canvases from the leading Venetian and Bolognese painters of his time.

Each painting was to represent an allegorical tomb commemorating one or more of England's illustrious political, intellectual, or military figures. Among those chosen to be so honored were Lord Somers, the Duke of Devonshire, William III, Isaac Newton, Lord Dorset, Sir Cloudesly Shovel, George I, Wharton, Addison, Cadogan, Godolphin, and of course, Archbishop Tillotson, Lord Stanhope, Boyle, Locke, and Sydenham.

McSwiny determined that three artists would be assigned to work on each canvas – one each for the figures, the architecture, and the landscape. Among the artists were Canaletto, Cimaroli, Pittoni, Sebastiano Ricci, Marco Ricci, Donato Creti, and Francesco Monti. The Duke of Richmond and Sir William Morice purchased most of these large full-color canvases between them.

In the meantime, McSwiny seems to have decided that further profit could be had from his project if a number of the works were engraved, bound together, and sold as a commemorative volume. Francis Haskell, to whose research we owe most of what is known about McSwiny, believes that a Bolognese artist, D.M. Fratta, was retained to make drawings of the paintings to that end.[30]

Soon after the Louvre's purchase of the Allegorical Tomb of Archbishop Tillotson, *Rosaline Bacou proposed that this grisaille was painted after the large finished canvas, as the work from which the engraving would be made, and that it was entirely by a single hand.*[31] *We believe that the other two examples exhibited here were painted in the same manner and for the same purpose.*

Finally in 1741 the volume Tombeaux de Princes grands capitaines et autres hommes illustres, qui ont fleuri dans la Grande-Bretagne vers la fin du XVII et le commencement du XVIII siècle *appeared. Only nine of the original compositions were included, rather than all twenty-four as had been promised in a pamphlet issued in the 1730s to solicit subscriptions and stimulate interest in the project.*

72

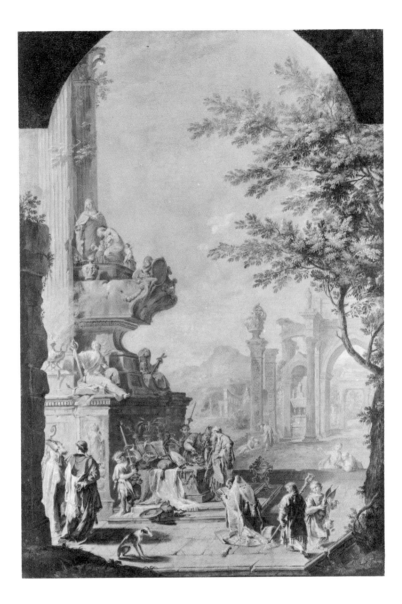

41 GIOVANNI BATTISTA PITTONI (Italian, 1687-1767). *Allegorical Tomb of Arch-bishop Tillotson*, ca. 1726-27. Oil on canvas. 31 1/2 × 20 7/8 in (80 × 53 cm). Musée du Louvre, Paris.

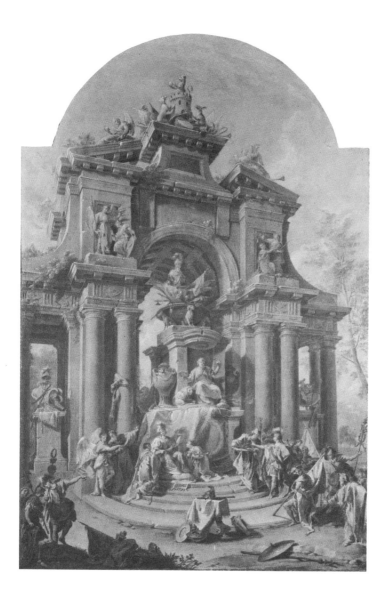

42 Giovanni Battista Pittoni. *Imaginary Monument to James, 1st Earl of Stanhope*, ca. 1726-27. Oil on canvas. 33 3/4 × 21 1/4 in (85.7 × 54 cm). John and Mable Ringling Museum of Art, Sarasota, Florida.

43 DONATO CRETI (Italian, 1671-1749). *Memorial to Charles Boyle, John Locke,*
and Thomas Sydenham. Oil on canvas. 33 1/4 × 21 3/8 in (84.5 × 54.3 cm). Suida
Manning Collection, New York.

44 DONATO CRETI. *The Rape of Europa*. Oil on canvas. 9 7/8 × 13 in (25.1 × 33 cm). Suida Manning Collection, New York.

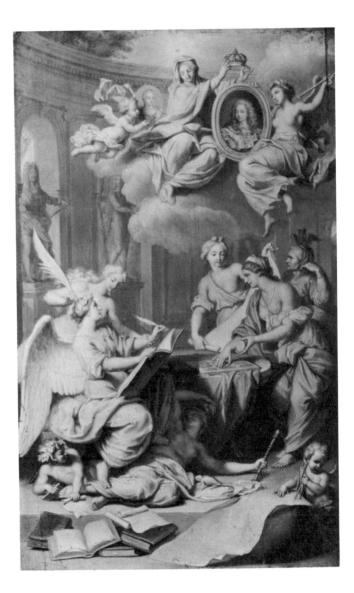

45 BERNARD PICART (French, 1673-1733). *Modello for the Frontispiece for the Annals of the French Monarchy*. Oil on panel. 15 3/4 × 9 13/16 in (40 × 25 cm). Musée des Beaux-Arts, Lille.

46 FRANÇOIS LEMOYNE (French, 1688-1737). *The King Offering Peace to Europe.* Oil on canvas. 51 3/16 × 34 5/8 in (130 × 88 cm). Musée des Beaux-Arts de Strasbourg.

This composition, which was engraved in 1737 by Laurent Cars, is the modello *for the frontispiece of a Sorbonne doctoral thesis by the future Cardinal and Prince-Bishop of Strasbourg, François-Armand-Auguste de Rohan-Soubise-Ventadour, who hung the painting in his bedroom.*[32]

We have here, in a reduced scale, a remarkable example of the skill, the flamboyance, and the authority displayed by Lemoyne in his great ceiling decorations.

François Lemoyne was the most brilliant painter of his day. He won the Premier Prix de Rome *at twenty-three but was not able to go to Italy at that time. At thirty he became a member of the Royal Academy. Ardent and anxious to compete with the Italian painters working in Paris, he agreed to decorate the choir of the Noviciat des Jacobins (now St. Thomas d'Aquin) in Paris for a meager sum. He interrupted the work for seven months to tour Italy, where the great ceiling decorations in Rome and Venice further stimulated his ambition.*

In 1731 he was commissioned to paint the Virgin's Chapel in the church of St. Sulpice, Paris. Two years later he started his work in the Salon d'Hercule at Versailles. Challenged by the importance of the commission and the colossal size of the ceiling, he painted L'Apothéose d'Hercule, a composition which included one hundred and forty-two figures, in order to glorify Louis XIV. It consecrated his fame; it also cost him his life. Emotionally unstable, grieved by the loss of his wife, and exhausted by his work, he was unable to withstand criticism and stabbed himself to death. He had been named Premier peintre du Roi *the year before.*

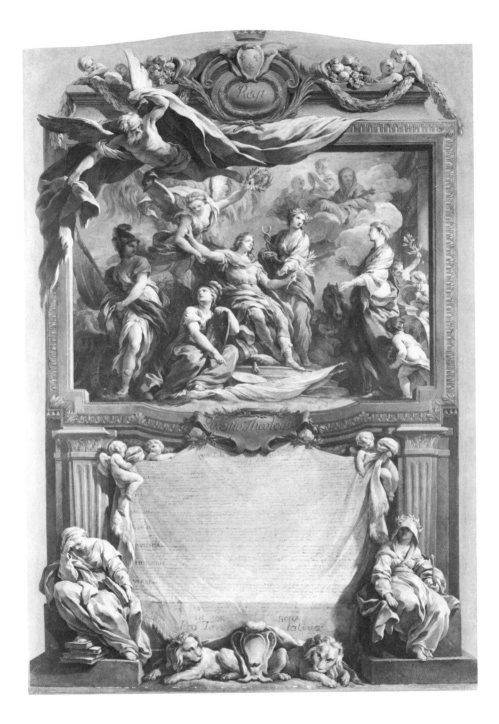

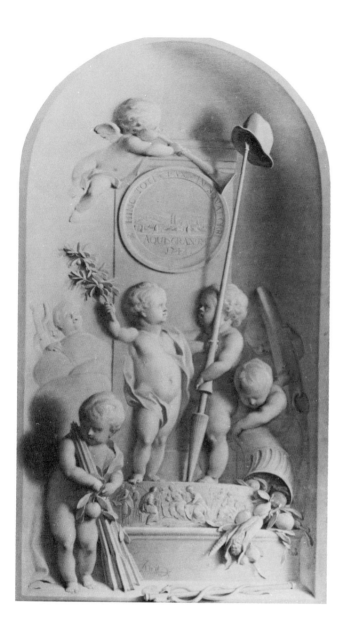

47 JACOB DE WIT (Dutch, 1695-1754). *An Allegory of the Treaty of Aix-la-Chapelle*,
1748. Oil on canvas. 84 × 46 in (213.4 × 117 cm). Spencer A. Samuels & Company,
Ltd., New York.

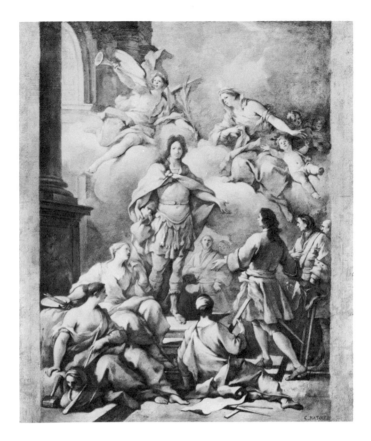

48 PIERRE JACQUES CAZES (French, 1676-1754). *Charity Presenting Officers and Soldiers to Louis XIV*. Oil on canvas. 23 × 18 7/8 in (58.4 × 48 cm). Musée des Beaux-Arts de Caen.

A modello *for the engraving which served as a frontispiece for Abbé Pérau's* Description historique de l'hôtel royal des Invalides, *published in Paris in 1754. Louis XIV commissioned the Invalides from the architect Libéral Bruant to house the wounded veterans of his many wars. The signature of Charles Natoire on the sketch is apocryphal.*[33]

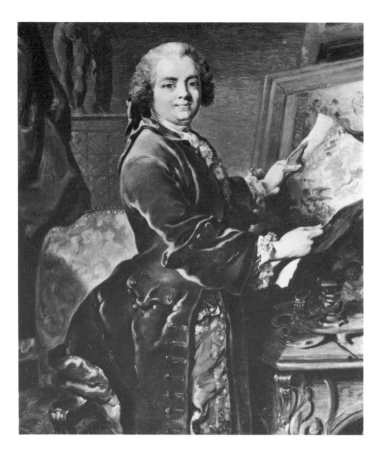

49 Louis Tocqué (French, 1696-1772). *Portrait of Jean-Baptiste Massé.* Oil on cardboard. 20 1/2 × 16 1/2 in (52 × 42 cm). Suida Manning Collection, New York.

A preliminary sketch for a large portrait, now lost, and possibly for the engraving done by Jean Georges Wille in 1755. Jean-Baptiste Massé, an engraver, painter of miniatures, and collector, holds in his hands a sketch for a Versailles ceiling by Le Brun.

Louis Tocqué, who was a member of the Academy, was best known as a painter of portraits of court figures and the wealthy bourgeoisie. His commissions also took him to Russia in 1757 on the invitation of Empress Elizabeth, and to Denmark in 1759 and 1769, where he painted the King and Queen. (From the catalogue of the exhibition *French Masters of the 18th Century* [New York: Finch College Museum of Art, February 27-April 7, 1963], no. 14.)

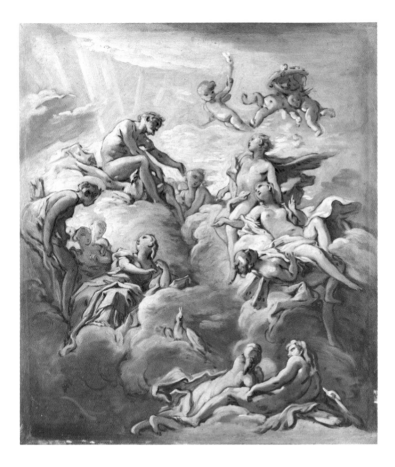

50 François Boucher (French, 1703-70). *The Gods of Olympus*. Oil on canvas. 20 × 16 3/4 in (50.8 × 42.5 cm). Musée des Arts Décoratifs, Paris.

51 FRANÇOIS BOUCHER. *Death of Socrates*. Oil on canvas. 16 1/8 × 21 7/8 in (41 × 55.5 cm). Musées du Mans.

François Boucher, an imaginative, sensitive, and indefatigable artist, dominated his time through his gifts and his productivity. His work includes important commissions like the decoration of the Cabinet des Médailles in the Bibliothèque Nationale and the Salle du Conseil in the Château of Fontainebleau, as well as drawings for an illustrated edition of Molière's plays, and engravings of more than one hundred works of Watteau.

He designed six great sets of tapestries for the Manufacture Royale de Beauvais and others for the Manufacture des Gobelins. His Story of Psyche, *woven at Beauvais, was repeated eight times during his lifetime for kings, ambassadors, and financiers: Boucher's influence reached as far as Stockholm and Moscow through the medium of tapestry.*

Boucher was the son of an obscure craftsman who sold designs for furniture and embroidery. In his father's shop, where he must have been put to work at an early age, he copied and invented ornaments, developing both his hand and his imagination. When he was seventeen the great painter Lemoyne, impressed by the gifts of the young artisan, agreed to teach him. Boucher assimilated the style of Lemoyne so well that master's and pupil's paintings have been confused at times, as was to happen later, when Boucher was Fragonard's master.

At the first opportunity Boucher left for Italy (1727). On his return his compositions of biblical subjects had opened the doors of the Academy to him, and he was officially admitted in 1734. He had married, the year before, a young girl of seventeen. With his position thus secured, and with a ravishingly beautiful young wife to pose for him, Boucher gave up religious themes and devoted himself to what best suited his sensuality and joie de vivre — *mythological and pastoral scenes.*

His paintings also suited the taste of Louis XV's hedonistic and frivolous court, and Boucher quickly became the most fashionable artist of the day. Solicited by the wealthy, absorbed by decoration projects for the theater which he loved, always ready to oblige with a sketch or a painting, Boucher was hard at work.

He soon became the favorite painter of Madame de Pompadour. The Marquise provided royal commissions for him and entrusted him with the decorations at Choisy and at her château of Bellevue. He rewarded her by portraying her as both Venus and Diana, as well as by doing her portrait. He painted her in her prime, as she was when she had captivated the King, and later he prolonged her beauty on canvas when the excessive duties of court life and a premature illness had taken their toll.

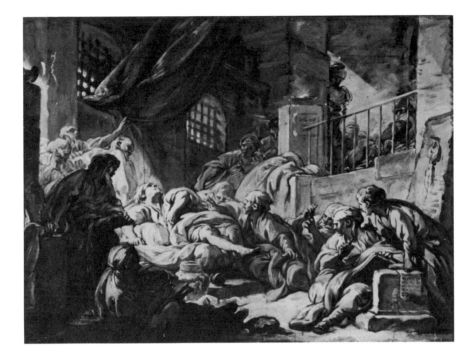

After her death, the Marquise's brother, M. de Marigny, Directeur des Bâtiments du Roi, became Boucher's protector and obtained for him the coveted title of Premier peintre du Roi.

The pastoral genre in which Boucher excelled delighted his patrons. His paintings of amorous outdoor games played by shepherds and shepherdesses, all dressed in silk in the latest fashions, answered the nostalgia for nature and excluded coarser reality. They were a unique mixture of refinement, elegance, and covert eroticism. A more overt eroticism blossomed in the mythological scenes, where nymphs, graces, and goddesses candidly displayed their lovely breasts and sumptuous buttocks.

Boucher's immense popularity began to decline in the last ten years of his life. He had to work too fast, to content himself with sketches executed in his studio. Also, tastes were changing: a moral reaction, a trend toward more severity in art, had begun to appear. Antiquity was still the inexhaustible source of inspiration, but artists were forsaking the loves of the gods for the more heroic themes of the Roman Republic.

Diderot expressed the shift in attitude toward Boucher in the bluntest of terms: "This man has everything – except truth."

52 FRANÇOIS BOUCHER. *Psyche Being Honored by the Gods,* ca. 1736-39. Oil on canvas. 16 3/4 × 21 1/4 in (42.5 × 54 cm.). Musées de Blois, Château de Blois.

The series of tapestries on The Story of Psyche *was commissioned from Boucher several years after the beginning of his collaboration with Oudry at the Manufacture de Beauvais. The series, woven beginning in 1741, was composed of five hangings:* The Arrival of Psyche, Abandonment, The Toilette, The Basket-Maker, *and* Wealth. *It seems that the painter originally had some hesitation over which subjects to execute, since his friend, the critic Bachaumont, had suggested ten episodes (from the story in La Fontaine). A comparison between Bachaumont's proposals and the subjects actually chosen by Boucher permits the identification of a number of sketches and preparatory studies.*

At the Salon of 1739, Boucher exhibited a "big painting fourteen feet wide by ten feet high, representing Psyche Conducted by Zephyr to the Palace of Love,*" which was intended to be executed at Beauvais as a tapestry for the King. The sketch exhibited here is believed to be the first conception for this large composition, although it was engraved by N. Pariseau under the title* Psyche Refusing the Divine Honors. *In fact, it corresponds to* The Arrival of Psyche, *which was based on the second motif Bachaumont suggested (Psyche received by the nymphs at the entrance to the Palace of Love). The painter made it the first episode in his series of five tapestries on* The Story of Psyche. *(From the catalogue of the exhibition* François Boucher: Premier Peintre du Roi *[Paris: Galerie Cailleux, May-June 1964], No. 15.)*

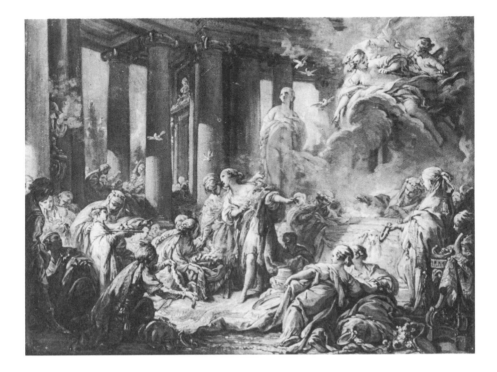

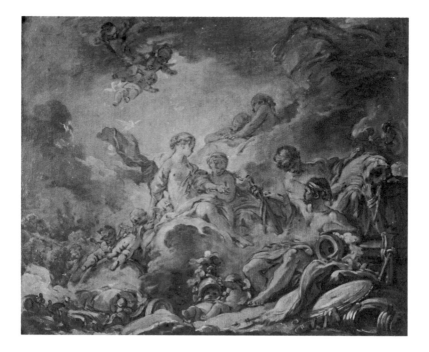

54 above FRANÇOIS BOUCHER. *Venus Asking Vulcan to Make Weapons for Aeneas*, 1757. Oil on canvas. 13 3/4 × 16 3/4 in (35 × 42.5 cm). Musée des Arts Décoratifs, Paris.
A sketch in grisaille for the painting Les Forges de Vulcain *(now in the Louvre) which served as a model for a tapestry executed by the Manufacture des Gobelins, in a series on* The Loves of the Gods.

53 opposite FRANÇOIS BOUCHER. *Vulcan's Forges*, before 1749. Oil on canvas. 18 × 28 1/2 in (45.7 × 72.5 cm). Musée du Louvre, Paris.
A grisaille sketch, on the theme of "Venus asking Vulcan to forge weapons for Aeneas," for a painting to be used as a model for a tapestry which was executed at the Manufacture de Beauvais in 1749. This is one of several paintings which Boucher executed, beginning in 1737, at the request of Oudry, the director of the Manufacture, whom Boucher succeeded after his death.

53, 54: The theme of Venus and Vulcan was treated over and over again by Boucher. At the age of twenty-nine he had painted a majestic vertical canvas, Venus Asking Vulcan to Forge Arms for Aeneas, *and in 1747 he executed the same theme, this time in an oval painting for the King's bedroom at Marly. This repetition of the same subject is one of the characteristic traits of Boucher's career. From 1735-40 on, Boucher was a man overburdened with work. As his commissions multiplied, he did not hesitate to return to the motifs he knew well and which he was able to execute easily.* (From ''François Boucher,'' *Petit Journal des Grandes Expositions,* Dossiers du Département des Peintures no. 2 [Paris: Musée du Louvre, July-October 1971].)

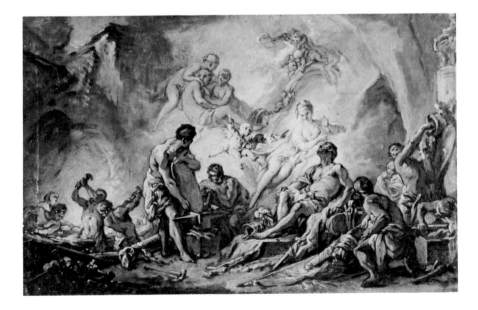

89

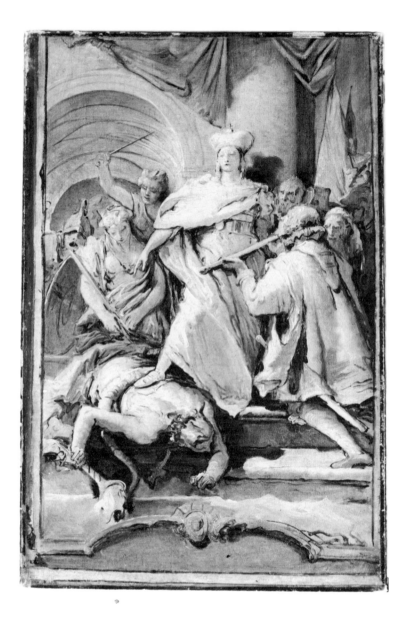

90

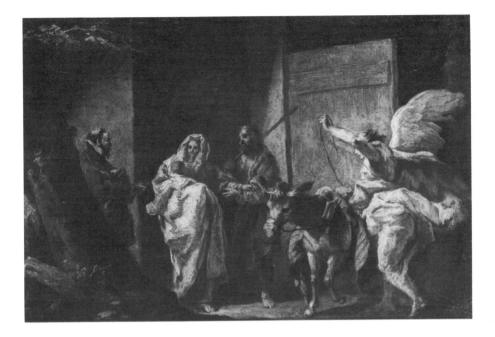

55 opposite GIOVANNI BATTISTA TIEPOLO (Italian, ca. 1696-1770). *Allegorical Scene: Triumph of the Church*, ca. 1760-70. Oil on canvas. 21 1/4 × 13 1/2 in (54 × 34.3 cm). Nelson Gallery-Atkins Museum, Kansas City: gift of Mrs. Gladys Lloyd Robinson.

Formerly thought to have been a study for an allegory of Empress Catherine of Russia, bearing the title Allegory of a Queen Crushing Vice. *It is still not known whether this work was ever executed on a large scale.*[34]

56 above GIOVANNI DOMENICO TIEPOLO (Italian, 1727-1804). *The Flight into Egypt*. Oil on canvas. 11 1/2 × 16 7/8 in (29.2 × 42.9 cm). Suida Manning Collection, New York.

A sketch for the fifth print in G. D. Tiepolo's suite on The Flight into Egypt.

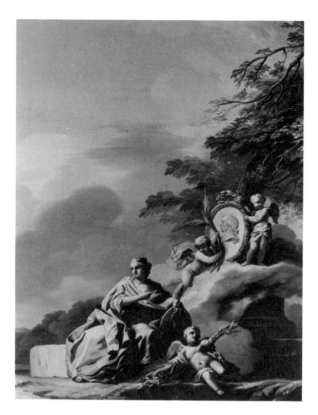

57 above José del Castillo (Spanish, 1737-93). *Homage to King Charles III*, 1775. Oil on canvas. 37 1/2 × 28 3/4 in (95.2 × 73 cm). Musée Goya, Castres.

58 opposite Jean-Joseph Delvigne (French, active ca. 1770). *The Bronze Serpent*. Oil on canvas. 45 7/8 × 35 7/16 (116.5 × 90 cm). Private collection, Paris.
 This XVIIIth-century grisaille, signed "Delvigne," can be safely attributed to a Jean-Joseph Delvigne from Tournai, who was given the title of "master" in 1770. No other painting has yet been attributed to him.
 Tournai was an active center for bas-relief imitations in grisaille in pre-Revolutionary and Napoleonic times. Piat Joseph Sauvage (1744-1818), who executed such grisaille decorations in Compiègne, Chantilly, and Rambouillet, was from Tournai, and he might have influenced Delvigne.

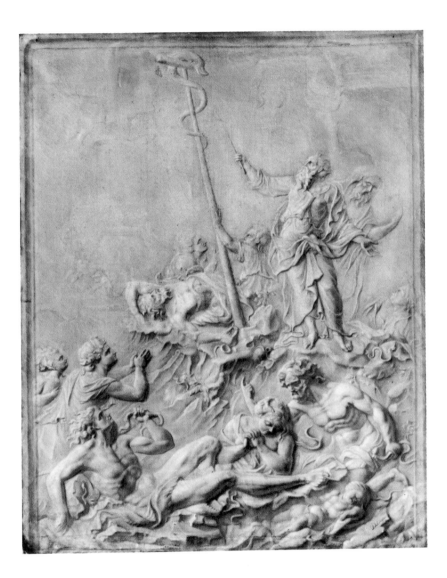

We have here another proof of the vitality of an enduring Flemish and Walloon
tradition of bas-relief imitation. It links Jacob de Wit (1695-1754; no. 47), Marten
Geeraerts (1707-91)–who painted eight monumental grisailles in the cathedral of
Cambrai, P.J. Sauvage, and Dominique Doncre (1743-1820), who influenced the
young Boilly (nos. 67,68), another master in grisaille trompe-l'œil.

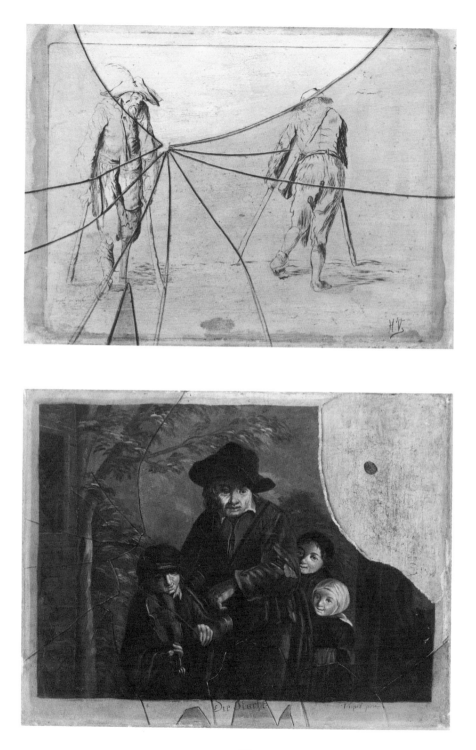

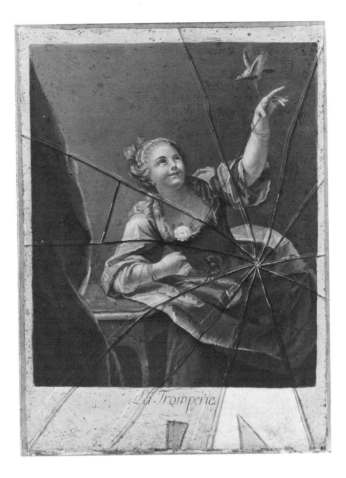

59 above left FRANÇOIS XAVIER VISPRÉ (French, 1730-90). *Two Beggars,* 1746. Oil on panel. 9 7/16 × 12 13/16 in (24 × 32.5 cm). Private collection, U.S.A.

60 below left FRANÇOIS XAVIER VISPRÉ. *Wandering Musicians.* Oil on canvas. 15 × 19 1/4 in (38 × 49 cm). Musée des Beaux-Arts, Dijon.
Trompe-l'œil imitating a torn engraving under a broken glass, after a painting by Adriaen van Ostade; the composition is reversed.[37]

61 above FRENCH, XVIIITH CENTURY. *The Deception.* Oil on canvas. 13 1/8 × 9 3/8 in (33.3 × 23.8 cm). Pete and Lesley Schlumberger, Houston.
This trompe-l'œil is a painted imitation of an engraving under broken glass. The composition of the painting was taken from an actual engraving by N.G. Dupuis, which was in turn taken from a painting of 1717, Girl with a Bird on a String, *by Jean Raoux (French, 1677-1734), now in the Ringling Museum of Art, Sarasota.*[38]

62 French, XIXth Century, Workshop of Ingres. *Odalisque in Grisaille*. Oil on canvas. 32 3/4 × 43 in (83.2 × 109.2 cm). The Metropolitan Museum of Art: purchase, Catharine Lorillard Wolfe Fund, 1938.

Ingres' Odalisque in Grisaille has been recently labeled by the Metropolitan Museum of Art as "Workshop of Ingres." [39] *It had previously been labeled by the Museum as "Ingres and Workshop" (for a brief time only) following the painting's thorough cleaning and restoration. Prior to that time the painting was identified in the Museum's catalogue* [40] *as being by Ingres.*

This painting contains passages which, for reasons of their unexpected awkwardness, arrest the viewer's attention. This awkwardness, most notably in the hands and feet of the Odalisque, appears inconsistent with Ingres' style when compared to his masterpieces. These areas appear as special curiosities in juxtaposition with the exquisite finesse and finish of the Odalisque's visage.

It may be reasonable to assume that the Grisaille Odalisque *is one of two things: the production of the young master and as yet unidentified assistants; or the production of Ingres' atelier (the question of assistants' roles aside) with the present condition of the painting representing various stages of completion.*

For the present, research and technical investigation are being devoted to the complete identification of hands present in the production of the Odalisque in Grisaille.

—J.C.

96

(In the discussion above the focus is on the odalisque figure in the painting and the implicit comparison of course is with that in the Grande Odalisque *of the Louvre. It is worth noting that in other respects also these are hardly the same paintings. In the* Grande Odalisque *there is a pipe and a censer on a tray in the right foreground. The figure is adorned with bracelets and the drape she holds gathered is patterned rather than plain. The drape conjoins in her hand with the handle of a fan which drops over the back of her thigh and is a focal picture element absent in the grisaille. There are also significant pictorial differences arising with the materials on which she lies, of greater variety and articulation in the* Grande Odalisque, *and in their disposition away from the figure and in draping it. Finally, the figure in the* Grande Odalisque *fills a far greater portion of the picture and the viewer is placed directly at the level of the odalisque and her gaze rather than above her.)*

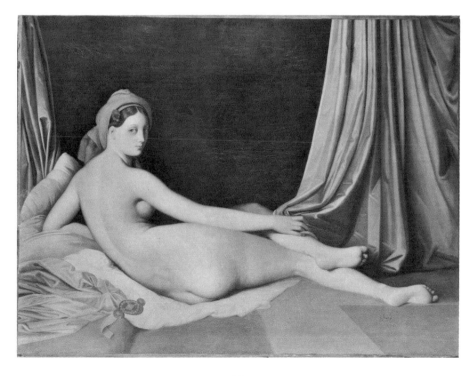

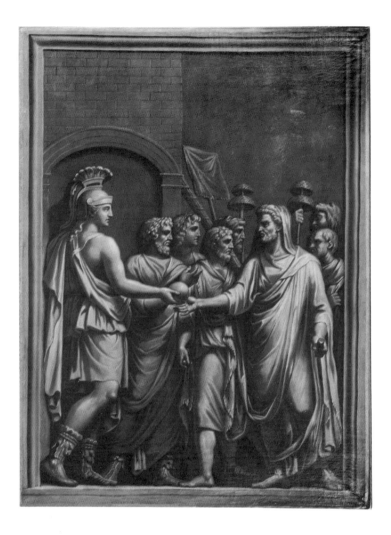

63 above CARLO LABRUZZI (Italian, 1765-1830). *Copy of a Roman Bas-Relief.* Oil on canvas. 29 × 21 in (73.7 × 53.4 cm). Musée des Beaux-Arts, Brest.

64 opposite PHILIPPE AUGUSTE HENNEQUIN (French, 1762-1833). *Allegory Commemorating the Birth of the King of Rome,* ca. 1811. Oil on canvas. 32 1/8 × 22 in (81.6 × 55.9 cm). Lent anonymously.
 Under the painting is the inscription translated below:

> *Victory formed his cradle.*
> *France gives him the sweet nectar of his mother's breast,*
> *and shows him, in the immortality of his august father,*
> *the high destiny for which his great name prepares him.*

The last owner of this painting was the Princess Clementine of Belgium, daughter

of *Leopold II, who had married Prince Victor Napoleon. At the time of the birth of the King of Rome, March 10,1811, Hennequin was in Belgium, but Louis Bonaparte, in conflict with his imperial brother, had already been forced to abdicate. It is therefore difficult to say for whom the* Allegory Commemorating the Birth of the King of Rome *was intended. Hennequin's memoirs seem to indicate that it was never executed on a large scale.*

The allegorical and heroic character of this composition borders on surrealism. The busts of Napoleon and Marie-Louise are the source of light and of life. An arcade opens on to the principal monuments of Rome, with the Tiber in the foreground. Behind it, the statue of Marcus Aurelius may be identified by the inscription on the base, but the artist has given it the pose and silhouette of the statue of Henri IV in Paris. (From the catalogue of the exhibition *Autour du Néoclassicisme* [Paris: Galerie Cailleux, March 1973], no. 16.)

65 Jean-Urbain Guérin (French, 1760-1836). *Henri IV and Gabrielle d'Estrée*. Oil on ivory. Diam: 2 7/8 in (6.8 cm). Musée des Beaux-Arts de Strasbourg: lent by the Société des Amis des Arts.

66 Gɪᴀᴄɪɴᴛᴏ Dɪᴀɴᴀ (Italian, 1730-1803). *Massacre of the Innocents*. Oil on canvas.
8 7/8 × 15 15/16 in (22.5 × 40.5 cm). Mr. and Mrs. Edward A. Maser, Chicago.

First sketch for the final bozzetto *for a fresco. This* bozzetto *is in the Minneapolis
Institute of Arts (Acc. No. 66.50). The fresco for which they were made has not been
identified, although it might have been in Naples, where Diana produced many of his
frescoes.* [41]

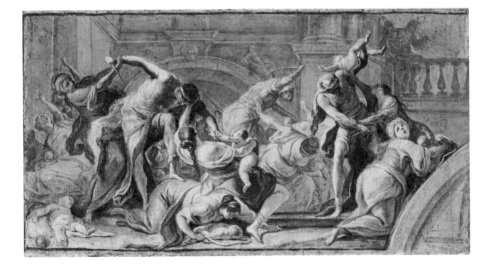

67 Louis Léopold Boilly (French, 1761-1845). *The Delicate Gift*. Oil on canvas.
18 1/8 × 14 11/16 in (46 × 37.3 cm). Musée des Arts Décoratifs, Paris: lent by the
Musées Nationaux de France.

68 Louis Léopold Boilly. *Maternal Advice.* Oil on canvas. 18 1/8 × 14 11/16 in (46 × 37.3 cm). Musée des Arts Décoratifs, Paris: lent by the Musées Nationaux de France.

The "maternal advice" is presented in written form, inscribed on the base of a statue which rests on the stove at the far left in the painting. The inscription reads:

Vois le perfide amour étouffant son flambeau
quant l'hymen de ses yeux enlève le bandeau.
*(See how treacherous Love extinguishes his flame
when Marriage removes the blindfold from his eyes).*

69 THÉODORE CHASSÉRIAU (French, 1819-56). *Silence*. Oil on canvas.
29 1/2 × 29 1/2 in (75 × 75 cm). Musée du Louvre, Paris.

Silence *is one of the few remaining fragments of the frescoes Chassériau executed
in the staircase of the Cour des Comptes in Paris. Only twenty-seven when he
received the commission, Chassériau worked four years on the project, interrupting
it only for his voyage to Algeria.*

*The Cour des Comptes was burned by the Commune in 1871. Although its frescoes
were only slightly damaged by the fire, they were left unprotected from the weather
except for dropcloths privately installed by Chassériau's nephew. They were still
preserved, after almost thirty years of exposure, when the burnt buildings were pulled
down to build the Gare d'Orsay. As the wreckers were starting their work, a
three-week delay was granted to a committee of artists and art lovers, who managed
to saw out some of the walls covered with the frescoes. Then, through an excess of bad
luck, the fragments thus saved and stored in the basement of the Louvre had to be
quickly removed when the Seine overflowed its banks in 1910. Careless handling and
a restorer's lack of sensitivity achieved their ruin. Only a fraction of the magnificent
decorations escaped the combined effects of fire, neglect, and flood.* [44]

The precious fragment exhibited here is the upper part of the standing figure of
Silence, *which was part of a group including* Meditation *and* Etude. *It and other
grisailles were located at the bottom of the stairs, where the light was poor. Théophile
Gautier saw in it the "genius loci, the initiator, calm and serene, who takes the hand
of the visitor, still deafened by the noise of the street, and invites him to climb the
stairs slowly and thoughtfully."* [45]

*Théodore Chassériau's precocious gifts and the help of an elder brother smoothed his
path into the art world. Ingres admitted him to his atelier when he was only twelve
years old, and at fourteen he was befriended by the poets Gérard de Nerval and
Théophile Gautier. His first paintings were accepted at the Salon when he was
seventeen. In his short life – he was only thirty-seven when he died – he painted murals
in three churches and a palace.*

*In 1840 Chassériau went to Rome and spent six months there. Ingres, who had had
such a strong influence on him, was then director of the Académie de France in Rome.
Chassériau was his favorite pupil, but the young painter emancipated himself from
his former master: "I see," he wrote to his brother, "that from many standpoints we
will never be able to agree."* [42]

On his return to Paris at the age of twenty-five he was commissioned to do an important decoration in the Cour des Comptes Palace. He interrupted the work temporarily to respond to an invitation from the Caliph of Constantine, whose portrait he had painted. Chassériau, like Delacroix some ten years earlier, discovered the exotic beauty of the Islamic world; under the spell of oriental color, he was bound to be influenced by Delacroix's palette. Baudelaire in fact accused him of imitating the Romantic master too blatantly, but he nevertheless saluted "the naïve audacity of the great masters" in Chassériau's precocious talent. [43]

Although clearly anchored in the French tradition, Chassériau developed a personal style: a blend of classical nobility, tender sensuality, and Romantic melancholy. He was to have a lasting influence on Puvis de Chavannes.

70 GUSTAVE MOREAU (French, 1826-98). *Pasiphaë*. Oil on canvas. 16 × 13 in (40.6 × 33 cm). Musée Gustave Moreau, Paris.

Pasiphaë, a figure in Greek mythology, was the wife of Minos, the legendary king after whom the Minoan civilization was named. Among the children she bore him were Ariadne and Phaedra. Because Minos failed to sacrifice a white bull to Poseidon, the god caused Pasiphaë to develop a lustful passion for the bull. From their union was born the Minotaur, a beast with the head of a bull and the body of a man.

Gustave Moreau had a quasi-mystical notion of art. For him, painting was "the language of God," [46] *meant to express noble thoughts; life was a fight between the powers of darkness and the powers of light. Biblical stories and Greek legends were to him an inexhaustible reservoir of images and allegories to express lofty aspirations, and carnal desires to be overcome.*

The subtle sensuality radiated by the youthful bodies of his heroes, saints, and villains, their androgynous appearance, the haunting scenes of horror, the dramatic settings of his large theatrical compositions – all contributed to Moreau's reputation for fin de siècle *decadence, to which Huysmans gave the weight of his talent when he described Moreau's paintings in* Against the Grain. *Such a Romantic image contrasts with Moreau's quiet and retired life of hard work, with his simplicity and gentleness.*

During his last six years Moreau taught at the Ecole des Beaux-Arts, counting Marquet, Matisse, and Rouault among his many students. His warmth, his en-

106

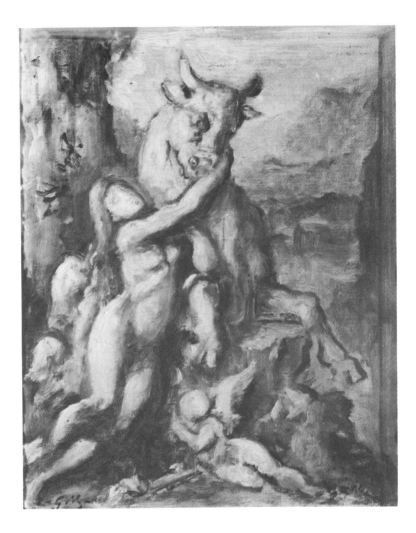

thusiasm for the great masters, his total lack of pretension and dogmatism, and his genuine openness towards the painting experiments of his students won him their devotion. He had faith in art and in young artists: "They say art is dead. It has hardly begun." [47]

Though he had his eyes well open on the past, Moreau appears today as a precursor. He was hailed as such by André Breton and the Surrealists for his visionary imagery; and his oil sketches, very free and almost abstract, came to be appreciated only with the advent of Abstract Expressionism.

107

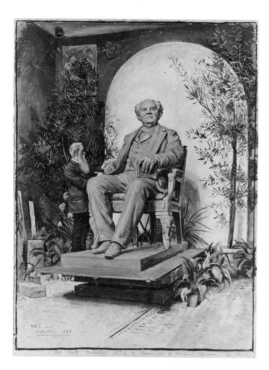

71 above H.E. TIDMARSH (British, active ca. 1884-1903). *Mr. Ball Modeling the Statue of Barnum, the American Showman*, 1887. Gouache on paper. 15 3/8 × 11 in (39 × 28 cm). Menil Foundation, Houston.

72 opposite FRANCIS B. CARPENTER (American, 1830-1900). *The Lincoln Family*, 1865. Oil on canvas. 27 × 36 1/2 in (68.5 × 92.7 cm). The New-York Historical Society.

A number of Lincoln family pictures, both engravings and lithographs, appeared around 1865. One engraver, J. C. Buttre, considered all of these works to be not only poor likenesses but also unworthy examples of the engraver's art. So he commissioned Francis Carpenter to paint a black-and-white oil painting of the Lincoln family as they appeared in 1861, and from this painting in late 1865 Buttre produced what has been called "the best of all Lincoln engravings."

The painting shows the President with his youngest son, Tad; Robert Todd Lincoln stands behind the table, and Willie is seated next to Mrs. Lincoln. Robert Todd Lincoln stated in 1908 that the portrait could not have been painted from life in 1861: Carpenter, he says, first met Abraham Lincoln in 1863, when the artist came to

Washington to paint a picture of the President reading the Emancipation Proclamation to his cabinet, but Willie Lincoln had died the year before. Furthermore, Robert Todd wrote that neither he nor his mother ever posed for Carpenter, and that the figures of President Lincoln and Tad were taken from a Brady photograph in which Lincoln is looking over a photograph album, not a Bible as has been claimed. There seems to be no doubt that Carpenter painted the picture from several separate photographs, arranging them in the composition to suit himself.

The painting apparently vanished after the engraving was made. However, around 1895 a collector of engravings, Warren C. Crane, paid a visit to a Mr. Probst, the executor of J. C. Buttre's estate. Probst showed Crane "a dirty, bent and broken canvas which he rescued from a rubbish heap." Although Probst had no idea who the artist had been, Crane bought the painting for $50 and took it to a critic, who immediately recognized it as the work of a good artist. Probst later came across some of Carpenter's letters, which indicated that he had painted the picture. He passed this information on to Crane who went to the artist in his New York studio. Carpenter confirmed that he had painted the picture for Buttre because there were so many inferior Lincoln portraits in existence at the time. Carpenter afterwards went to Crane's home many times to look at the painting, which he considered far superior to his Emancipation Proclamation; *each time he was supposed to bring his brush to sign it, and each time he forgot, so that* The Lincoln Family *remains unsigned to this day. Crane presented the painting, along with the letters which led to the identification of the artist, to The New-York Historical Society on April 6, 1909.* (From George H. Smyser, ''The Lincoln Family in 1861: A History of the Painting and Engraving,'' *Journal of the Illinois State Historical Society* 22 [1929], pp. 357-61.)

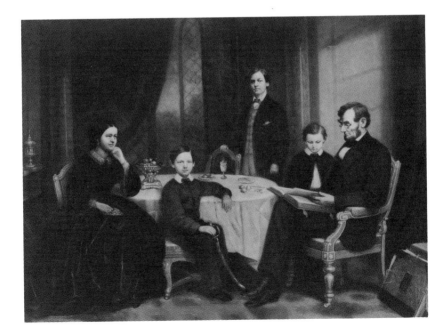

73 GUSTAVE DORÉ. *The Overturned Cradle*, 1870-71. India ink wash and gouache on paper. 17 5/16 × 13 3/8 (44 × 34 cm). Musée des Beaux-Arts de Strasbourg.

A shell has pierced the wall of a room; to the right a cradle is overturned, and an infant lies in a pool of blood. The mother, paralyzed with fear, her robe tangled in the bedclothes, stares at her child. Through the breach there is a glimpse of a cupola, perhaps the Pantheon's.[49] This gouache is dated 1870-71, a period which saw the shelling of Paris by the Prussians, the Commune, and the forces against the Commune.

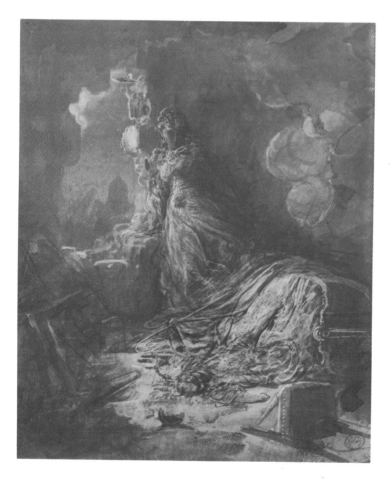

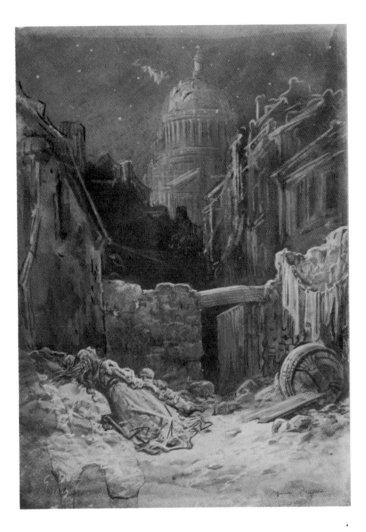

75 GUSTAVE DORÉ. *Poor Woman of London*, 1869. India ink wash and gouache on paper. 18 1/8 × 12 in (46 × 30.5 cm). Musée des Beaux-Arts de Strasbourg.

In a sordid, ruined square, out of which opens a perspective of streets dominated by the cupola of St. Paul's, a sleeping beggar, her infant near her, dreams. In the starry night, a flight of angels hovers above the cupola.[50] *This is a preparatory design for an illustration to* London: A Pilgrimage, *by Blanchard Jerrold (London, 1872).*

74 GUSTAVE DORÉ (French, 1832-83). *Ship among the Icebergs.* India ink wash on bistre paper. 23 1/4 × 17 7/8 in (59 × 45.5 cm). Musée des Beaux-Arts de Strasbourg.

A project for an illustration of Coleridge's Rime of the Ancient Mariner *(London: Doré Gallery, 1876). The crew is massed on the prow to ward off the blocks of ice, which surround the distressed ship.* [48]

And now there came both mist and snow,
And it grew wondrous cold:
And ice, mast-high, came floating by,
As green as emerald.

And through the drifts the snowy clifts
Did send a dismal sheen:
Nor shapes of men nor beasts we ken—
The ice was all between.

The ice was here, the ice was there,
The ice was all around:
It cracked and growled, and roared and howled,
Like noises in a swound!

At length did cross an Albatross,
Thorough the fog it came;
As if it had been a Christian soul,
We hailed it in God's name. (I, 51-66)

76 ODILON REDON (French, 1840-1916). *Profile of a Breton Woman*, ca. 1890-95. Oil on prepared paper. 20 1/4 × 14 5/8 in (51.5 × 37.1 cm). University Art Museum, Berkeley.

The Profile of a Breton Woman *is reminiscent of a lithograph Redon made in 1886 entitled* Profile of Light, *in which a young woman wearing a pointed bonnet has a similar melancholy appearance. Her lips are thin and tight, her nose is long and straight, and her eyes are cast down. Her face is drenched in light. Redon made several other profiles of young women, all turned to the left with eyes cast down.* Druidesse, *a lithograph of 1892 (in his album of* Songes), *and* Young Virgin, *a lithograph of 1893, have a spiritual kinship with the* Breton Woman.

Odilon Redon's unusual childhood seems to have fostered the moody and visionary world he created. Doctors having ruled out school as too strenuous for his frail health, he was left to grow up alone, with endless leisure and hardly any schooling, on a large family domain called Peyrelebade in southwestern France until he was eleven. He played with the children of the local peasants, roamed around the rather desolate country, and followed his natural inclination to daydream. The primitive and ungainly people, the monotonous pine forest, the misty marshes marked him for life. Sensitive and imaginative, he stored up "impressions on which he was to draw for many years to come." [51]

Charcoal drawings, engravings, and lithographs occupy a very large place in Redon's œuvre. He seemed to have had a predilection for black, calling his charcoal drawings "my blacks." [52] *Charcoal, an austere medium, lent itself well to the strange and somber mood of so many of his compositions.*

114

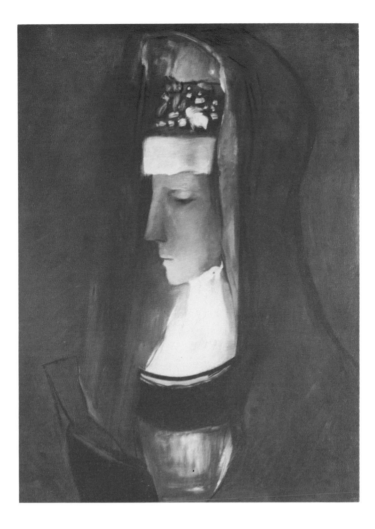

His emotional attachment to Peyrelebade and the dread of losing the heavily mortgaged property seem to have weighed greatly on him. When the place was finally sold, Redon entered a new life. At that time he started working with bright pastels. He confessed that "colors contain a joy which relaxes me; besides, they sway me toward something different and new."[53]

Redon traveled little, but saw the Pyrenees, northern Spain, and Holland (making "a pilgrimage to the holy places where Rembrandt lived"). And he saw "the gentle and melancholy Brittany, which I love so much."[54]

77　above FREDERIC REMINGTON (American, 1861-1909). *The Return of Gomez to Havana*. Oil on canvas. 27 × 40 in (68.6 × 101.6 cm). The Museum of Fine Arts, Houston: Hogg Brothers Collection.
　Published in Collier's, *March 10, 1899*.

78　opposite FREDERIC REMINGTON. *Indian Fire God*. Oil on canvas. 40 × 27 in (101.6 × 68.6 cm). The Museum of Fine Arts, Houston: Hogg Brothers Collection.
　Published in Harper's New Monthly Magazine, *September 1897, under the title* The Going of the Medicine-Horse, *as an illustration for an article by Remington,* "The Great Medicine-Horse."

79 JEAN LÉON GÉRÔME (French, 1824-1904). *Moses in the Wilderness–The Battle of Alameck*, before 1895. Oil on canvas. 11 1/2 × 15 1/2 in (29.2 × 39.4 cm). Schweitzer Gallery, New York.

This painting was one of a series of ten grisailles executed for the Amsterdam Bible, *published in 1895. Since the illustrations were to be photogravures, Gérôme chose the medium of grisaille. There were one hundred illustrations in the Bible, ten by each of the artists, among whom was Tissot. The* Amsterdam Bible *of 1895 is quite rare, but it was also published in Italy under the title of* La Biblia Illustrata, *edited by H. Ogetti. The subject of this work is the Battle of Alameck, in which Moses' companions hold his arms upraised during the course of the battle, for if he lowered his arms the tide of battle would turn against his troops.*[55]

80 THOMAS EAKINS (American, 1844-1916). *The Fairman Rogers Four-in-Hand*, 1899. Oil on canvas. 23 1/2 × 35 5/8 in (59.7 × 90.5 cm). The St. Louis Art Museum.

Reduced version in black and white of the picture in the Philadelphia Museum of Art. The St. Louis picture was made to be photographed for Rogers's book, A Manual of Coaching *(Philadelphia, 1900).*

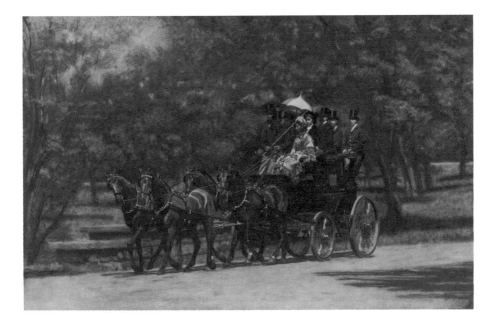

81 AMERICAN, XIXTH CENTURY, NEW ENGLAND ORIGIN. *Compote with Fruit and Flowers,* ca. 1840. Watercolor and ink on paper. 15 × 12 in (38.1 × 30.5 cm). Menil Foundation, Houston.

An unusual example of a type of painting popular in mid-XIXth-century America, this "theorem painting" employs only black and grays. Theorem paintings were made using stencils; the medium was oil on velvet or watercolor on paper, and color was common. The technique was taught primarily to young ladies in seminaries, for whom it was a personal expression and an accomplishment. This one shows, in addition to the stencil patterns, traces of freehand drawing in some details.[56]

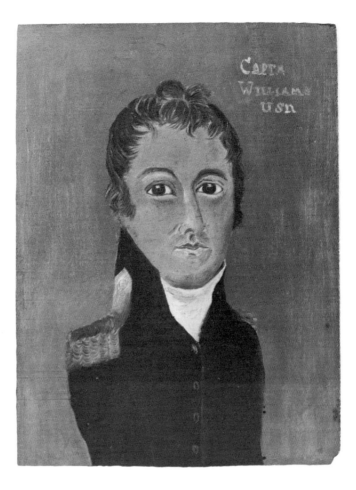

82 AMERICAN, XIXTH CENTURY. *Captain Williams, U.S.N., Sag Harbor Ship's Captain.* Oil on board. 5 1/2 × 4 in (14 × 10.2 cm). Edmund Carpenter, New York.

83 GEORGES ROUAULT (French, 1871-1958). *Way to Calvary*, 1891. Oil on canvas. 15 3/16 × 26 3/8 in (38.5 × 67 cm). Wadsworth Atheneum, Hartford: gift of Alfred Jaretzki.

Georges Rouault's parents were from Brittany. His father was a skilled cabinetmaker who had strong religious convictions but also held strong social and anticlerical views: he refused to put his children in a Catholic school. Rouault seemed to have inherited his father's uncompromising character. His maternal grandfather kindled his interest in art early. "On Sundays, he would walk along the quays of the Seine with his grandson, in search of reproductions of Manet's and Courbet's work, which he pinned on his walls between busts of Racine and Corneille." [57]

From age fourteen to nineteen Rouault was apprenticed to a stained-glass artist. In the evening he attended drawing classes at the Ecole des Arts Décoratifs. In December 1890 he enrolled in the Ecole des Beaux-Arts, where, a year later, Gustave Moreau became his teacher. Pierre Courthion noted, "It was probably under Gustave Moreau's direction that he painted The Road to Calvary *in 1891."* [58] *The*

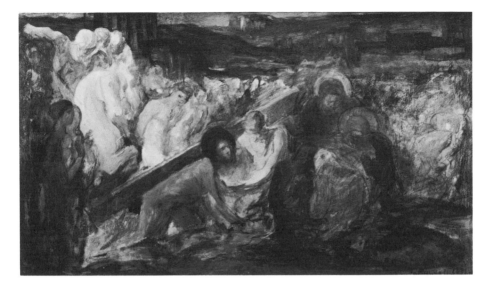

brown hues may have been inspired by Rembrandt, whom Rouault admired greatly.

Rouault became Moreau's favorite pupil. There was a certain spiritual kinship between them, a common distaste for the world. After his death, Rouault became the curator of the paintings Moreau had left, along with his house, to the state.

In spite of such close association and Moreau's early influence, Rouault developed a personal style and iconography. Unlike Moreau, who massed mythological figures in theatrical compositions or provided Romantic settings for his biblical subjects, Rouault painted humble scenes and whores, clowns, workers, judges. He had the courage to paint the vulgar and the grotesque and he did it with compassion. The simplified forms and concentrated colors of his evangelical landscapes reach an intense lyricism. He achieved a secret pathos in some of his closeup representations of Christ and in the series of copperplates he made for Miserere and War.

84 EUGÈNE CARRIÈRE (French, 1849-1906). *Portrait of Paul Gauguin*, 1891. Oil on canvas. 21 1/2 × 25 3/4 in (54.6 × 65.4 cm). Yale University Art Gallery: bequest of Fred T. Murphy, B.A. 1897.

Eugène Carrière was born in Gournay, Seine-et-Marne, in 1849, the youngest of nine children of a struggling insurance salesman. In 1851 the family moved to Strasbourg, where Eugène grew up. His mother, the daughter of a country doctor, managed to provide a warm family life in spite of real poverty. At nineteen he left his parents to earn a living working for a lithographic printer in St. Quentin. The collection of Quentin de la Tour's portraits in the city museum there inspired him to become a painter.

In 1870 the Franco-Prussian War broke out; Carrière was taken prisoner in Alsace and sent to Dresden. The German doctor at the prison camp, observing his ability to sketch, had him allowed some freedom in the city. His visits to the museum, where at his leisure he could study Rubens, Veronese, and Rembrandt, sharpened his ambitions. Back in Paris he attended the Ecole des Beaux-Arts and tried for the Prix de

Rome. Two unsuccessful attempts, in 1875 and 1876, barred him from an official career.

Recognition came slowly and only after years of extreme hardship that were courageously shared by his wife. His personality and the seriousness of his work won him the sympathy of critics and artists like Roger Marx, Jacques-Emile Blanche, and Rodin.[59]

Though Carrière is best known for tender and misty scenes of maternal love – they brought him fame and wealth – his best work may well be his portraits of men, particularly the lithographs. The lithographic portraits he made of Verlaine, of Rodin, of Edmond de Goncourt on his deathbed, have a subtle and forceful presence – an undisputable authority.

85 ALEXANDRE THÉOPHILE STEINLEN (French, 1859-1923). *Vision of Paris*. Oil on canvas. 13 × 16 in (33 × 40.6 cm). Musée du Louvre, Paris.

Steinlen, a native of Lausanne who established himself in the teeming artistic milieu of Montmartre in the early 1880s, was an able etcher, draftsman, and lithographer as well as painter. His work– always sarcastic, and frequently deriding the Parisian proletariat– appeared in most of the French humor magazines, including Le Chat Noir, Le Croquis, La Revue Illustrée, Le Canard Sauvage, *and* Le Rire. *He illustrated Anatole France's* L'Affaire Crainquebille *and Maupassant's* Le Vagabond, *and he also made lithographed posters, bringing his art to the people in the street as well as to the literati.*

The grisaille exhibited here is probably a first preparatory sketch for Paris, *a poster Steinlen made to advertise Emile Zola's book of that name, which had first appeared in serial form in* Le Journal. *The poster was printed by Verneau and measured 140 by 200 centimeters. A beautiful lyrical study, freely treated, the sketch uses grisaille in the manner of Carrière, but its style nevertheless shows the hand of a lithographer. It is especially interesting for its relationship to the Art Nouveau movement.*[60]

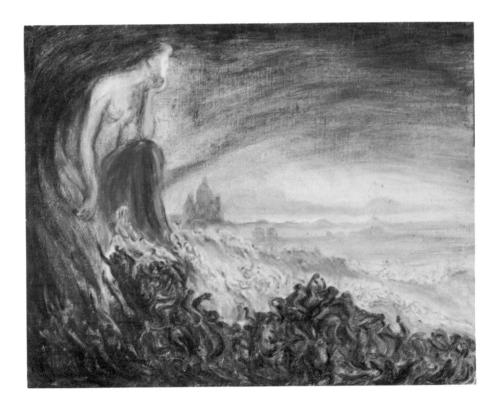

127

86 JEAN FAUTRIER (French, 1898-1964). *Glaciers*, 1926. Oil on canvas. 18 1/8 ×
21 1/2 in (46 × 54.6 cm). Private collection, U.S.A.

The Glaciers *were painted in the Tyrol during the summer of 1926. Palma*
Bucarelli wrote about Fautrier's use of gray: "All the colors in Fautrier's painting
may be related to a fundamental gray; they imply in a way, though distantly, a
chiaroscuro. Something in his painting comes from the oldest and most noble French
tradition; precisely, it is this reference of each color to a hypothetical neutral gray
which gives a relief to the most mute tones." [65]

When he was ten years old, on the death of his father, Jean Fautrier was taken to
London by his mother. A child prodigy, he was admitted to the Royal Academy at
thirteen and had his first exhibition at fifteen.[61] *Wounded in World War I, he*
remained in France after the war and at twenty-one took up painting seriously.

Paris was then the great artistic junction of the world. Braque, Léger, Gris, and
Picasso were producing masterpieces, and a new generation of painters was coming
up, stimulated by André Breton. Fautrier, however, steered away from both Cubism
and Surrealism; after producing a few traditional canvases, he emerged in 1926 with
dark landscapes (the Glaciers*) that were brilliantly brushed in a style somewhat*
reminiscent of Turner.

During this black period, which he called "noir-noir," [62] *Fautrier also painted*
strange oversized flowers, standing nudes, and haunting, gloomy pictures of tortured
fowl and game which seem premonitory of the Hostages *series that he painted in the*
'40s. In 1928, he also executed thirty-four lithographs to illustrate Dante's Inferno.
The portfolio was commissioned by Gallimard but never published.

During World War II Fautrier worked in hiding. In 1943-44 he produced a
stunning series of semiabstract paintings, the Hostages, *evocative of mutilated faces*

128

and bodies. The paintings were a response to his agonizing experience of hearing the executions of hostages taking place on the other side of the wall which surrounded the park and house where he had taken refuge.[63]

These paintings were done with a technique he had developed in the '30s that combined patches of thick impasto on lightly painted paper glued to the canvas, with thin outlines in watercolor and sprinklings of pastel powder. It was to remain his personal medium. He perfected it in the 1950s and painted a series of basic objects (a can, a box, a glass), as well as evocations of nudes or landscapes. His work became increasingly abstract.

Though his reputation never really crossed the Atlantic, Fautrier has been acclaimed in literary circles by such men as Jean Paulhan, Francis Ponge, and André Malraux, who wrote the foreword to a catalogue of one of his exhibitions.[64] *In the art world, Sir Herbert Read, Pierre Restany, Michel Tapié and others have credited him as the originator, with Wols, of ''l'art informel''; Wols himself is said to have had the highest regard for him, and Dubuffet's admiration has been noted as well. Palma Bucarelli, the director of the Galleria Nazionale d'Arte Moderna in Rome, has published a critical volume on his life and work.*

87 MAN RAY (American, born 1890). *Suicide*, 1917. Airbrushed tempera on card-
board. 23 1/2 × 18 in (56.6 × 45.7 cm). D. and J. de Menil Collection, Houston.

 "At the time I painted Suicide, *the beginning of a series done with an airbrush or
compressed-air instrument, I had been rather severely criticized for vulgarizing art
with mechanical tools. That and other run-ins with galleries depressed me and I
observed that I would sit behind the painting and arrange a gun in front so that I could
pull a string and have the bullet go through to my heart. However, I feared this would
provoke further criticism in resorting to another mechanical instrument. But there
was also the thought that my suicide might give pleasure to some people. Just giving
the title and remaining alive was a contradiction I would enjoy alive. So here I am.*

 "At the time I was reading a play by a Russian writer, a melodrama called The
Theater of the Soul, *by N. Evreinof, which suggested the title."* [66]

<div align="right">—MAN RAY</div>

88 FERNAND LÉGER. *Two People with a Dog on a Staircase,* 1920. Ink wash on
paper. 11 × 8 1/2 in (28 × 21.6 cm). Menil Foundation, Houston.

88, 89: Fernand Léger, a born painter, was the son of a Norman cattle raiser, who died while he was still a child. Léger's exceptional vigor, his frank and direct approach to his art and his taste for the popular may be ascribed to his peasant descent.

At nineteen, having spent two years working with an architect in Caen, he left for Paris to study architecture. His uncle, a stern tutor, had consented to architecture as a lesser evil than painting. When the uncle found out that his nephew had given up architecture for drawing and painting, he cut off his allowance. But no hardships – not even a world war– could distract Léger from his vocation.

Cézanne, whom he discovered at the retrospective exhibition of 1907, became at that point a major influence. Léger has acknowledged his debt: "Cézanne taught me the love of forms and volumes; he made me concentrate on drawing." [67]

Léger was unaware at first of Picasso's and Braque's experiments – he lived in Montparnasse and they lived in Montmartre – but he met them through Kahnweiler in 1910. At that time he had already developed his own very personal brand of Cubism: "Delaunay and I were far from the others. They painted monochrome, we polychrome." [68] *But Léger also kept his distance from Delaunay, who liked "nuance," while he wanted "contrasts."*

Color, which he used mostly pure and unmixed, had a tonic effect on him. He considered it "a vital necessity, a primal element, indispensable to life, like water and fire." [69] *Despite such a strong statement, Léger produced many monochrome gouaches, and several of his compositions were to be painted entirely in grisaille* (Acrobats in Gray, *1944;* Dance, 1st state, *1929) or partly in grisaille* (Two Sisters, *1935, and* Three Musicians, *1932, with large gray figures on a yellow background).*

The reduction of color to gray, which is ideally suited for modeling, reveals Léger's basic interest in sculptural forms. By applying the gray modeling only to objects and figures and retaining the color for backgrounds or pure patches, Léger could achieve the maximum contrast.

All problems to him were "formal problems," which he attempted to solve through la plastique. *He not only talked of "plastic values" and "plastic beauty," but also of "plastic life" and "plastic orientation."*

Léger has been called a primitive. Although there is nothing primitive in his highly elaborate compositions with faceted planes, cylinders, cones and spheres, which he so masterfully produced in 1910 and developed further after the war, the term rings true when applied to the large figurative compositions of the '30s and '40s. Frontal and expressionless figures, grouped in a schematic landscape or silhouetted against a monochrome background, have the robust directness and simple charm of naïve representations. The Trapeze Artists and the Juggler *is an example of the clarity and simplicity Léger was able to achieve through his great sophistication and the forcefulness of his genuine popular spirit.*

89 FERNAND LÉGER (French, 1881-1955). *The Trapeze Artists and the Juggler*, 1943. Oil on canvas. 44 1/16 × 50 in (112 × 127 cm). Private collection, Paris.

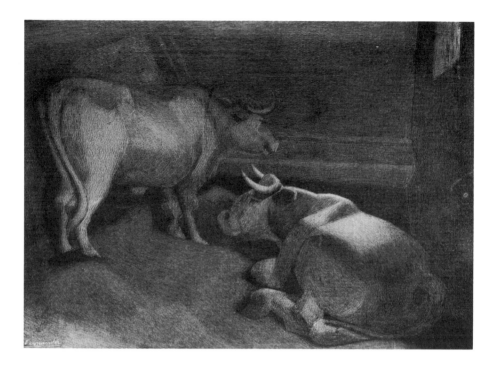

90　Louis Fernandez (French, born Spain, 1900-73). *Cows in the Stable,* 1955.
Eggbase paint on canvas mounted on celotex and set on a cradle. 9 1/2 × 12 3/4 in
(24.1 × 32.3 cm). D. and J. de Menil Collection, Houston.

90-94: Born in Oviedo, Spain, in 1900, Louis Fernandez went to Paris when he was twenty-four years old and lived there until his death. He got to know Braque, Ozenfant, Giacometti, Mondrian, Miró, and, of course, Picasso. Stimulated by Surrealism, he ventured in its territory for a short while. He looked at Cubism but never imitated it, rather going beyond it in his search to depict the spiritual reality of things.

Each of Fernandez' paintings is the outcome of innumerable preparatory studies in gray, and each one is rigorously structured into small tonal values, or intervals of luminosity. With stern geometric simplicity of forms and deep, rich colors, strictly shaded, Fernandez achieves a unique combination of severity and sumptuousness.

On the following pages:

91 above left LOUIS FERNANDEZ. *Portrait of a Resistance Fighter,* 1944-45. Gouache on paper mounted on wood. 30 5/8 × 25 5/8 in (77.8 × 65.1 cm). D. and J. de Menil Collection, Houston.
Portrait of a young man killed in the French Resistance during World War II. Commissioned by his mother and made from a passport photograph, the portrait was said to have been such a haunting likeness that she would not keep it.

92 below left LOUIS FERNANDEZ. *Skull,* 1955. Eggbase paint on canvas pasted on masonite. 18 1/8 × 15 in (46 × 38.1 cm). D. and J. de Menil Collection, Houston.

93 above right LOUIS FERNANDEZ. *Two Pigeons V,* 1963-64. Oil on canvas. 13 × 16 in (33 × 41 cm). Private collection, U.S.A.

94 below right LOUIS FERNANDEZ. *Two Pigeons VIII,* 1965. Oil on canvas. 13 × 16 in (33 × 41 cm). Private collection, U.S.A.

136

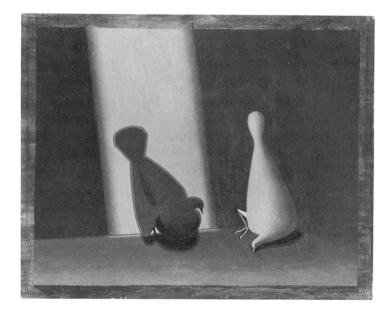

95 REGINALD MARSH (American, 1898-1954). *Hudson Burlesk*, 1949. Oil on composition board. 12 1/8 × 15 31/32 in (30.8 × 40.5 cm). Wadsworth Atheneum, Hartford: gift of William Benton.

The half-light in this scene painted in brown, gray and dull pink relates it to night paintings, an important grisaille subject. Marsh was inclined to muddy colors, well suited to the grayness of New York.

Reginald Marsh's grandfather was a wealthy Chicago meatpacker, his father a painter who could afford to be unsuccessful. Reginald, the proverbial third generation, had to support himself. After college he started peddling his drawings to newspapers and magazines. Gifted, but with little academic training–one year "by the pedants of the Yale Art School" [70]*– he taught himself to draw by sketching vaudeville for the New York* Daily News. *"I must have covered and drawn at least four thousand vaudeville acts. . . . It was very good training because you had to get the people in action."* [71] *Later, he went back to school through the influence of the painter Kenneth Hayes Miller, with whom he also studied.*

With Miller he shared a love for New York. "I never go to the country; there is nothing there," Miller told him. And Marsh wrote, "I felt fortunate indeed to be a citizen of New York, the greatest and most magnificent of all cities, in a new and vital country, whose history had scarcely been recorded in art." [72] *He liked the waterfront, the Bowery, Union Square, the subways, but most of all, people: workers, sidewalk merchants, bums, and salesgirls and stenographers, whom he invariably depicted as young, bouncy, and bosomy.*

In the summer Marsh went to Coney Island, "sometimes three or four days a week." He liked the crowds there. "Crowds of people in all directions, in all positions, without clothing, moving– like the great compositions of Michelangelo and Rubens." [73]

At night he sketched burlesque, which he considered "extremely pictorial." He

138

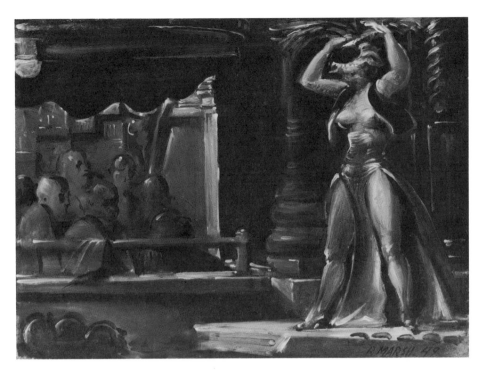

noted too that the burlesque show was "the only entertainment, the only presentation of sex that [the poor man] can afford." [74]

Thomas Merton left this brief account of Marsh: "When I got back to New York I had lost most of my temporary interest in religion. My friends in that city had a religion of their own: a cult of New York itself, and the peculiar manner in which Manhattan expressed the bigness and gaudiness and noisiness and frank animality and vulgarity of this American paganism.

"I used to go to the burlesque and hang around Fourteenth Street with Reg Marsh, who was an old friend of my father's, and who is famous for painting all these things in his pictures. Reginald Marsh was (and I suppose still is) a thick-set man of short stature, who gave the impression that he was a retired lightweight prize fighter. He had a way of talking out of the corner of his mouth, and yet, at the same time, his face had something babyish and cherubic about it, as he looked at the world through the simple and disinterested and uncritical eyes of the artist, taking everything as he found it, and considering everything as possible subject matter for one of his Hogarthian compositions, provided only it was alive." [75]

96 MARK TOBEY (American, born 1890). *Prophetic Light-Dawn*, 1958. Tempera on paper. 60 × 34 3/4 in (152.4 × 88.3 cm). The Museum of Fine Arts, Houston.

97, 98: Gray does not seem to have been an indifferent color to Magritte. As early as 1926 he painted a gray picture Le Village Mental. *From then on he often used grays and browns extensively.* L'Abandon *(1929) and* La Légende des Guitares *(1930), both in the collection of André Breton until 1961, are painted entirely in monochrome, the first in brown, the second in gray with black outlines and white highlights. A gouache of 1935,* La Gâcheuse *(a naked woman with a skull instead of a head), is a pure grisaille perhaps because it was done for the monochrome cover design of a magazine.*[76]

*Two themes recur in Magritte's œuvre for which he used grays or grayish blues: a phantom sailing ship, made of sea (*Le Séducteur*), and an eagle turned into a mountain peak. The petrified eagle appears in 1936 under the title* Le Précurseur. *It reappears in 1938 as a pure grisaille,* Le Domaine d'Arnheim, *and keeps reappearing under various titles (*L'Appel des Cimes, Les Pas Perdus*).*

In the '50s, and probably as early as the late '40s, Magritte expanded the theme of petrification to a variety of subjects. In Le Chant d'Amour– *a lyrical and gripping picture– a pair of lovers, half human (lower part), half fish (upper part), turned to stone, are seated on a rock by the sea, while a ship passes in the distance. In 1950 Magritte painted* Le Château Hanté: *a desolate landscape of rocks emerging above waters is struck by petrified lightning. The enormity of turning light into stone is deemphasized by a meticulous rendering which makes the picture look like an illustration for a primer. From the same year there is* L'Art de la Conversation: *a kind of Stonehenge monument with blocks of gray stone piled up in such a way that some of them form the word* rêve *("dream"). The grayish stones are often silhouetted against skies in stereotyped colors, but with* La Parole Donnée, *a petrified apple caught up between stone slabs, painted also in 1950, Magritte again suppresses all color.*

In 1951 Magritte painted several grisailles about petrification: Souvenir de Voyage III *(no. 97),* Journal Intime I, Le Chant de la Violette. *In the following years and until his death he executed other grisaille petrificiations, taking up the title* Souvenir de Voyage *again in 1955 for a large canvas (no. 98).*

These pictures are relatively matter of fact and superficially less disturbing than the previous romantic scenes. Only familiar objects[77] *are represented. The large* Souvenir de Voyage *(1955) looks almost like a family group painting. Yet the absence of drama, the perfect banality of the scenes render them truly ominous. We are no longer threatened by an exterior phenomenon. We feel threatened in our souls. We are in another world – a world without exit – where space itself has been metamorphosed.*[78]

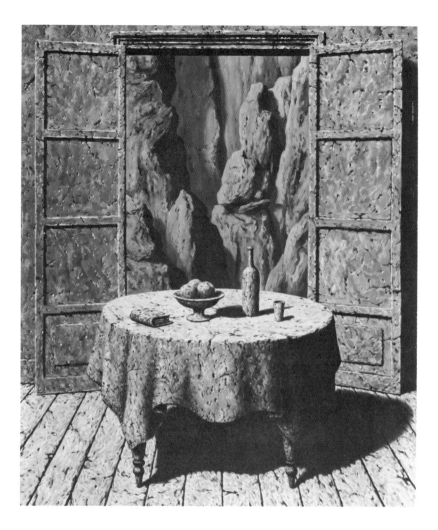

97 RENÉ MAGRITTE (Belgian, 1898-1967). *Souvenir de Voyage III*, 1951. Oil on canvas. 33 × 25 1/2 in (83.9 × 64.8 cm). Adelaide de Menil, New York.

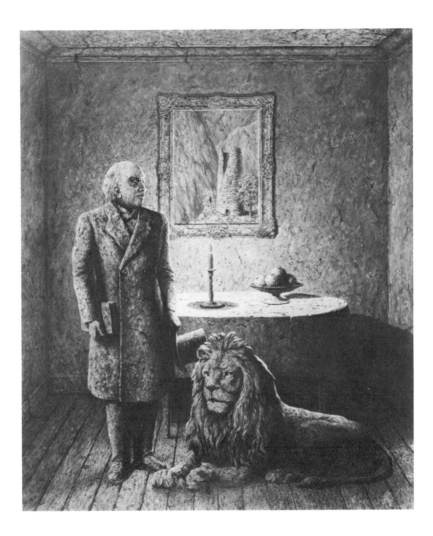

98 René Magritte. *Souvenir de Voyage,* 1955. Oil on canvas. 63 7/8 × 51 1/4 in (162.2 × 130.2 cm). The Museum of Modern Art, New York: gift of D. and J. de Menil, 1959.

Grisaille holds an important place in Picasso's œuvre; he has reached summits with a palette reduced to drab tones.

Late in 1901 he replaced the bright colors he had been using with subdued ones, predominantly blues. In most of 1902 he painted "in blue monochrome except when an occasional portrait commission required more varied color." [79] *Throughout the "Blue Period" (1902-1904) he kept on using the same low-key palette. In 1905 he "began to use pinks and tans, occasionally contrasted with ochres, olives or pale blues, but often with . . . a reddish monochromatic effect."* [80] *Thus the latter part of 1905 and much of 1906 have been called his "Rose Period."*

The revolution he accomplished with the Demoiselles d'Avignon *in 1907 was a plastic one. The colors did not differ much from the blues, the pinks, and the terra cotta previously used. But in 1909 and during the whole period of Analytic Cubism, Picasso abandoned color to paint monochromes of grays and browns. "Picasso and Braque . . . kept to their modulations of gray and tan through most of 1913 with only occasional and tentative deviations."* [81]

Throughout his life Picasso occasionally painted in gray monochromes; the 1930 figure exhibited here is one of many grisailles. Two years later he executed, entirely in grays, a seated woman which Alfred Barr described as "one of the most sphinx-like of Picasso's images." [82] Guernica *(1937), probably his most famous work and one of the great murals of all time, is done only in grays, whites, and blacks. Another response to totalitarian atrocity,* Charnel House *(1944-45), is also a grisaille.*

Picasso's periodic return to austere grays, like his constant switching between the graphic simplicity of a few lines and baroque profusion, seems a kind of natural contraction and expansion, almost an organic necessity of his pulsating genius.

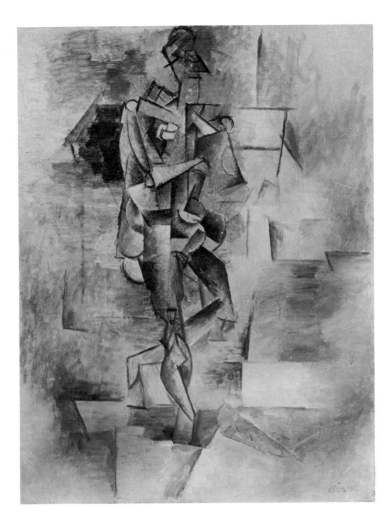

99 PABLO PICASSO (Spanish, 1881-1973). *Nude Woman,* Winter 1909. Oil on can-
vas. 28 1/2 × 21 1/2 in (72.4 × 54.6 cm). D. and J. de Menil Collection, Houston.

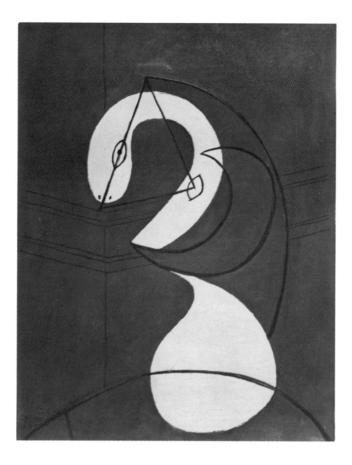

100 PABLO PICASSO. *Figure,* January 25, 1930. Oil on panel. 25 3/16 × 18 1/2 in
(64 × 47 cm). Lent anonymously.

101 PABLO PICASSO. *Reclining Woman Reading*, December 5, 1960. Oil on canvas. 51 1/8 × 76 3/4 in (129.9 × 195 cm). Fort Worth Art Center Museum: Benjamin J. Tillar Trust.

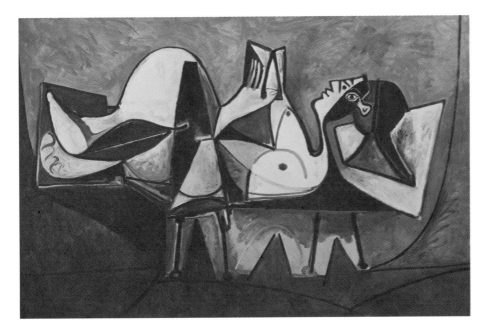

102 MAX ERNST (French, born Germany, 1891). *Ecole des Cristaux*, 1960. Oil on panel. 6 5/16 × 23 1/4 in (16 × 59 cm). Madame Jean Gruner, Paris.

103 VICTOR VASARELY (Hungarian, born 1908). *Galets A*, 1959. Oil on plywood mounted on a drawing board. 26 3/4 × 23 7/8 in (68 × 60.6 cm). D. and J. de Menil Collection, Houston.

104　ALBERTO GIACOMETTI (Swiss, 1901-66). *Seated Man*, 1954. Oil on canvas. 31 3/4 × 25 1/2 in (80.6 × 64.6 cm). D. and J. de Menil Collection, Houston.

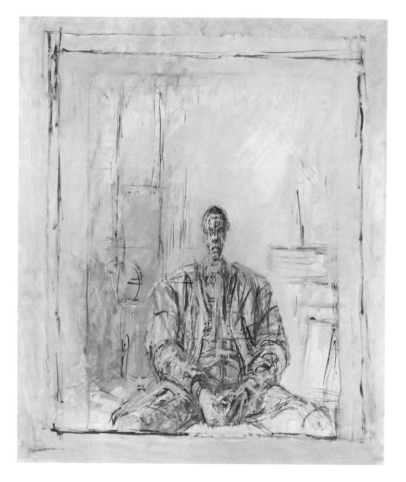

105 HEDDA STERNE (American, born Rumania, 1916). *Vertical Horizontal,*
1963-64. Oil on canvas. 59 × 41 1/2 in (149.8 × 122.5 cm). D. and J. de Menil
Collection, Houston.

*"These simple-seeming horizontal bands are so structured as to size and color
relation and paint surface that they evoke a large and spacious world of light: not an
infinite mystical world, but one of open, clear landscape—most particularly, the
landscape of sea, pale sand and sky. Given nothing but a disciplined range of greys
and creams, and a precisely calculated though softly painted set of 'stripes,' one can
almost smell and feel the soft salt air."* [83]

106 opposite JASPER JOHNS (American, born 1930). *Voice*, 1964-67. Oil on canvas with objects. 96 × 69 1/2 in (243.8 × 176.5 cm). D. and J. de Menil Collection, Houston.

below *Voice* in an earlier state. Photograph courtesy of the artist.

107 JAMES ROSENQUIST (American, born 1933). *Necktie,* 1961. Oil on canvas. 14 ×
10 in (35.5 × 25.4 cm). Henry Pearson, New York.
 The artist has specified that Necktie *always be hung in the upper left hand corner of
a wall.*

108 FRANK STELLA (American, born 1936). *Sketch Les Indes Galantes*, 1962. Oil on canvas. 71 1/2 × 71 1/2 in (181.6 × 181.6 cm). Walker Art Center, Minneapolis.

109 VICTOR BRAUNER (French, born Rumania, 1903-66). *Complexe Saphique,* 1963. Oil on canvas. 39 3/8 × 31 7/8 in (100 × 81 cm). Alexandre Iolas Gallery, New York (Louise Ferrari, Houston).

Closely connected at first with the Surrealist group, Victor Brauner rapidly emerged as a profoundly original painter. By the 1940s he had developed a personal iconography with which he expressed his intense psychological anxieties.

Dark monochromes or quasi-monochromes are not exceptional in his work, yet, on the whole, Victor Brauner is a colorist. His colors, audacious as well as subtle, often fresh like folk art decorations, are always masterfully blended.

Astrology, alchemy and the occult fascinated him. He was an avid reader and a brilliant conversationalist. Yet painting was his medium. With painting he expressed his deepest emotions and his search for truth. He wrote in his diary, "To paint is life, real life, my life." [84]

110 ROBERT INDIANA (American, born 1928). *The X-5*, 1963. Oil on canvas. 108 × 108 in (274.4 × 274.4 cm). Whitney Museum of American Art, New York.

111 RICHARD ARTSCHWAGER (American, born 1924). *High Rise Apartment*, 1965. Liquitex on celotex. 24 × 31 in (61 × 78.8 cm). D. and J. de Menil Collection, Houston.

"The painting, if I remember correctly, has a tan wood-grain formica frame, a black ground, and a speckly image of a building sitting in it. It is not one of a series, nothing as tight as that, but I have been doing paintings of this general character for the last twelve years or so. The color, or reduced palette? That's from a longstanding preoccupation with drawing. In drawing one says, sometimes, 'try to make the paper come alive,' or something like that. One doesn't usually say 'make the canvas come alive,' but rather 'make the paint come alive' as itself (paint) or as what it dissembles (rocks, trees, etc.). The board on which I paint has an aggressive character, like a coarse paper, and maintains its character very well. So these are paintings, but they partake very much of drawing. This painting represents itself, and also represents something like it, but smaller, perhaps one-quarter the size, or even less. The coarseness of the image does that. But the frame tends to stay its own size, probably because it is clean, fine, and sharp. On the other hand, the speckles are not just speckles, but have some diverse character, so they might be credibly as big as parts of an actual building." [85]

—RICHARD ARTSCHWAGER

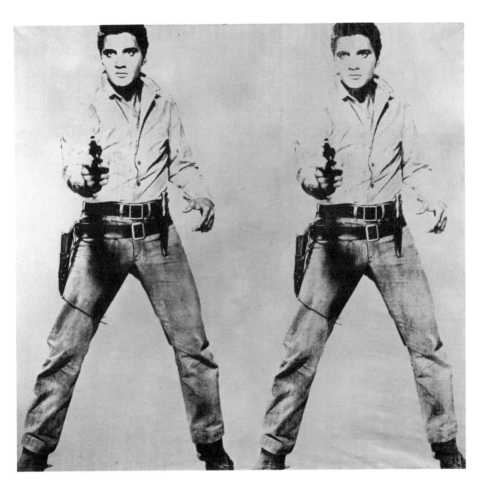

112 ANDY WARHOL (American, born 1930). *Elvis III*, 1962. Silkscreen on canvas.
82 × 82 in (208.2 × 208.2 cm). Tom and Dana Benenson, Mill Valley, California.

113 John Willenbecker (American, born 1936). *Labyrinth 8.X.72,* 1972. Acrylic on masonite. 64 × 48 in (162.5 × 122 cm). A.M. Sachs Gallery, New York.

114 JOSEF ALBERS (American, born Germany, 1888). *Never Before*, 1971. Oil on masonite. 44 × 48 in (111.8 × 122 cm). The Metropolitan Museum of Art: gift of Josef Albers, 1972.

115 JOHN BAEDER (American, born 1938). *Klamath, Calif.*, July 1972. Acrylic on canvas. 42 × 66 in (106.7 × 167.6 cm). Mr. and Mrs. Judd Maze, New York.

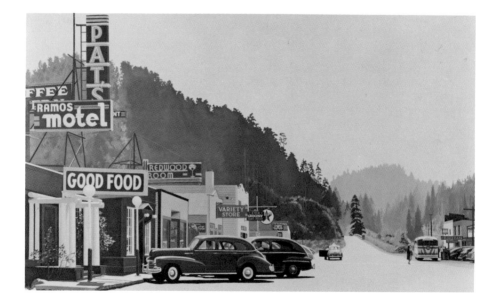

CHUCK CLOSE. *Phil*, 1969. Synthetic polymer on canvas. 108 × 84 in (274.4 × 213.4 cm). Whitney Museum of American Art, New York: gift of Mrs. Robert M. Benjamin.

This painting was committed to the exhibition but unfortunately had to be withdrawn by the lender.

CATALOGUE NOTES

1. We are indebted for this hypothesis to Professor Harry Bober of The Institute of Fine Arts, New York University.

2. Paul Kristeller considered these paintings school works painted from Mantegna's drawings under his eye (see his *Andrea Mantegna* [London: Longmans, Green and Co., 1901], p. 372). In the exhibition catalogue *Masterpieces from Montreal,* compiled by David Carter (Montreal Museum of Fine Arts, 1966), p. 26, it is noted that in 1961 it was suggested that they were by an artist in the circle of Mantegna who had assisted in the monochrome frescoes of the funerary chapel of the church of S. Andrea in Correggio.

3. Olle Wanscher, *The Art of Furniture* (New York: Reinhold, 1966), p. 94.

4. *Styles, meubles, décors, du Moyen Age à nos jours* (Paris: Librairie Larousse, 1972), p. 42.

5. Paliard, "L'Abondance," *Gazette des Beaux-Arts* (1891), pp. 308-16.

6. *Entretiens sur les vies et sur les ouvrages des plus excellents peintres anciens et modernes,* p. 291. File of *L'Abondance,* Service de Documentation du Département des Peintures du Musée du Louvre.

7. File of *L'Abondance,* Musée du Louvre.

8. As quoted in Paliard, p. 312.

9. *Inventaire des tableaux du Cabinet du Roi, placés à la Surintendence des Batimens de sa Majesté à Versailles fait en l'Année 1784,* file 9, p. 35. File of *L'Abondance,* Musée du Louvre.

10. File of *L'Abondance,* Musée du Louvre. The inventory was published by Fernand Engerand in 1899.

11. Page 116. File of *L'Abondance,* Musée du Louvre.

12. "Un ritratto di Pietro Paolo Rubens a Genova," *Paragone* 67 (1955), pp. 46-52. Translated by Donald Jenkins.

13. Maurizio Fagiolo Dell'Arco, *Il Parmigianino* (Rome: M. Bulzoni Editore, 1970), no. 215.

14. Charles Sterling to Dominique de Menil, October 30, 1973. Editor's translation.

15. Terence Mullaly, "A Modello by Andrea Vicentino," *Minneapolis Institute of Arts Bulletin* 54 (1965), p. 35.

16. Charles Sterling to Dominique de Menil, October 30, 1973.

17. Published in Felix Sluys, *Didier Barra et François de Nome, dits Monsu Desiderio* (Paris: Editions du Minotaure, 1961), as *Ville en Ruine.* The group of "apostles" at lower left, as well as the two silhouettes above the arch, are probably later additions by another hand. However, the two elongated figures in oriental garb seem to be by François de Nome.

18. Louis Réau, "L'Enigme de Monsu Desiderio," *Gazette des Beaux-Arts,* ser. 6, vol. 13 (1935), pp. 242-51. A résumé of this article appeared as "Monsu Desiderio," *Bulletin de la Société nationale des Antiquaires de France* (1935), pp. 6-9.

19. *Fantastic Visions of Monsu Desiderio* (Sarasota, Fla.: John and Mabel Ringling Museum of Art, 1950). Preface to the catalogue by A. Scharf. And *Monsu Desiderio* (Rome: Galleria dell' Obelisco, 1950). Preface to the catalogue by G. Urbani.

20. Sluys, *Didier Barra et François de Nome,* p. 61.

21. R. Causa, "Francesco de Nome, detto Monsu Desiderio," *Paragone* 75 (1956), pp. 30-46.

22. Sluys, p. 19.

23. Julius Held to Osborne Gallery, New York, March 26, 1966.

24. Catalogue of the exhibition *Nicolas Poussin et son temps* (Rouen: Musée des Beaux-Arts, April-May 1961), p. 60.

25. Pierre Rosenberg, *Rouen, Musée des Beaux-Arts, Tableaux français du XVII^e et italiens des XVII^e et XVIII^e siècles,* Inventaire des collections publiques françaises, no. 14 (Paris: Editions des Musées Nationaux, 1966), p. 120.

26. Edith Hamilton, *Mythology* (New York: New American Library, Mentor Books, 1964), pp. 285-86.

27. John A. Pinto, "Five Allegorical Figures: An Italian Painting in the Fogg Museum, and the Problems Concerning Its Date," *Fogg Art Museum Acquisitions Report* (1968), pp. 65-79.

28. Information supplied by the lender. The Kress Collection picture is illustrated in Renato Roli, *Donato Creti* (Milan: M. Spagnol, 1967), color plate I.

29. B.J.A. Renckens to Dominique de Menil, November 5, 1973.

30. Francis Haskell, *Patrons and Painters: A Study in the Relations between Italian Art and Society in the Age of the Baroque* (London: Chatto & Widners, 1963), pp. 287-91.

31. Catalogue of the exhibition *Venise au XVIII^e Siècle* (Paris: Musée de l'Orangerie, 1971), no. 197.

32. Catalogue of the exhibition *Watteau et sa génération* (Paris: Galerie Cailleux, 1968), no. 88.

33. Information supplied by the lender.

34. Antonio Morassi, *A Complete Catalogue of the Paintings of G. B. Tiepolo* (London: Phaidon Press, 1962), p. 36.

35. Information supplied by the lender.

36. Information supplied by the lender.

37. Information supplied by the lender.

38. We are grateful to Kent Sobotik, Chief Curator, The Museum of Fine Arts, Houston, for this discovery.

39. *Report on Art Transactions, 1971-73* (New York: The Metropolitan Museum of Art, June 20, 1973), pp. 19-21.

40. Charles Sterling and Margaretta M. Salinger, *French Painting: A Catalogue of the Collection of The Metropolitan Museum of Art,* vol. 2 (Greenwich, Conn.: The Metropolitan Museum of Art, 1966), pp. 7-9.

41. Information provided by the lender.

42. Quoted in Jean-Louis Vaudoyer, preface to the catalogue *Exposition Chassériau* (Paris: Musée de l'Orangerie, 1933), p. 20.

43. Charles Baudelaire, *OEuvres Complètes* (Paris: Gallimard, Collection Bibliothèque de la Pléiade, 1954), p. 571.

44. Eight or nine fragments remain, the largest one being *Peace.*

45. Henry Marcel, *Chassériau* (Paris: Collection l'Art de notre temps, 1911), pp. 63-66. See also Ary Renan, "Théodore Chassériau et les peintures du Palais de la Cour des Comptes," *Gazette des Beaux-Arts* (February 1898), pp. 12, 90-103.

46. Written in 1897, a year before his death, and quoted in the introduction to the *Catalogue sommaire des Peintures, Dessins, Cartons, et Aquarelles du Musée Gustave Moreau* (Paris: Musée Gustave Moreau, 1926).

47. *Ibid.*

48. Hans Haug, *Gustave Doré: Catalogue des œuvres originales et de l'œuvre gravé conservés au Musée des Beaux-Arts de Strasbourg* (1954), p. 17.

49. *Ibid.,* p. 14.

50. *Ibid.,* pp. 14-15.

51. John Rewald, "Odilon Redon," from the catalogue of the exhibition *Odilon Redon, Gustave Moreau, Rodolphe Bresdin* (New York: The Museum of Modern Art, December 4, 1961-February 4, 1962), p. 10.

52. *Ibid.,* p. 39.

53. *Ibid.*

54. Fragment of a letter by Redon to Edmond Picard, quoted in André Mellerio, *Odilon Redon* (Paris: Société pour l'Etude de la Gravure Française, 1913), p. 82.

55. Information supplied by the lender.

56. Information supplied by Leah and John Gordon, American Folk Art Gallery, New York.

57. Pierre Courthion, *Georges Rouault* (New York: Harry N. Abrams, Inc., 1962), p. 13.

58. *Ibid.*, p. 374.

59. All biographical information was taken from Richard T. Hirsch's introduction to the catalogue of the exhibition *Eugène Carrière: Seer of the Real* (Allentown, Pa.: Allentown Art Museum, November 2, 1968-January 26, 1969).

60. File of *Vision de Paris,* Service de Documentation du Département des Peintures du Musée du Louvre.

61. Jean Paulhan, *Fautrier l'enragé* (Paris: George Blaizot, 1949).

62. Palma Bucarelli, *Jean Fautrier* (Milan: Il Saggiatore, 1960), p. 197.

63. *Ibid.*, p. 81.

64. André Malraux, foreword to the catalogue of the exhibition *Les Otages* (Paris: Galerie Drouin, October 26-November 17, 1945).

65. As quoted in the catalogue of the exhibition *Jean Fautrier* (Paris: Musée d'Art Moderne de la Ville de Paris, April-May 1964), p. 39.

66. Man Ray to Dominique de Menil, October 20, 1973.

67. Catalogue of the exhibition *Fernand Léger, 1881-1955* (Paris: Musée des Arts Décoratifs, June-October 1956), p. 76.

68. *Ibid.*, p. 102.

69. Catalogue of the exhibition *F. Léger* (Basel: Galerie Beyeler, August-October 1969), p. 46.

70. Lloyd Goodrich, *Reginald Marsh* (New York: Harry N. Abrams, Inc., 1972), p. 20.

71. *Ibid.*, p. 24.

72. *Ibid.*, p. 34.

73. *Ibid.*, p. 38.

74. *Ibid.*, p. 37.

75. Thomas Merton, *The Seven Storey Mountain* (New York: Doubleday, Image Books, 1970), pp. 147-48.

76. *Bulletin International du Surréalisme,* no. 3.

77. While in Houston in December 1965, Magritte was asked why he painted lions so often. He replied, "The lion is a familiar animal to children, as well as to grownups."

78. Information given by David Sylvester, London.

79. Alfred H. Barr, Jr., *Picasso: Fifty Years of His Art* (New York: The Museum of Modern Art, 1946), p. 26.

80. *Ibid.*, p. 45.

81. *Ibid.*, p. 90.

82. *Ibid.*, p. 176.

83. Sarah C. Faunce, "Reviews and Previews," *Art News,* vol. 62, no. 8 (December 1963), p. 14.

84. As quoted in the catalogue of the exhibition *Victor Brauner* (Paris: Musée National d'Art Moderne, June 2-September 25, 1972), p. 117. Victor Brauner's tombstone bears this inscription.

85. Richard Artschwager to Dominique de Menil, November 1, 1973.

Installation Photographs

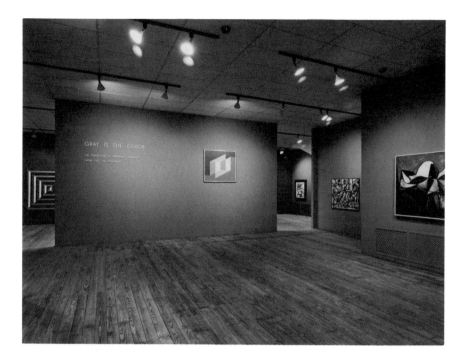

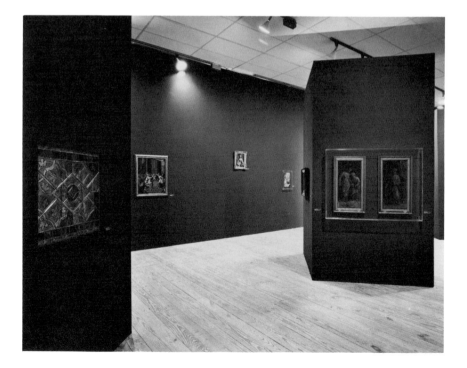

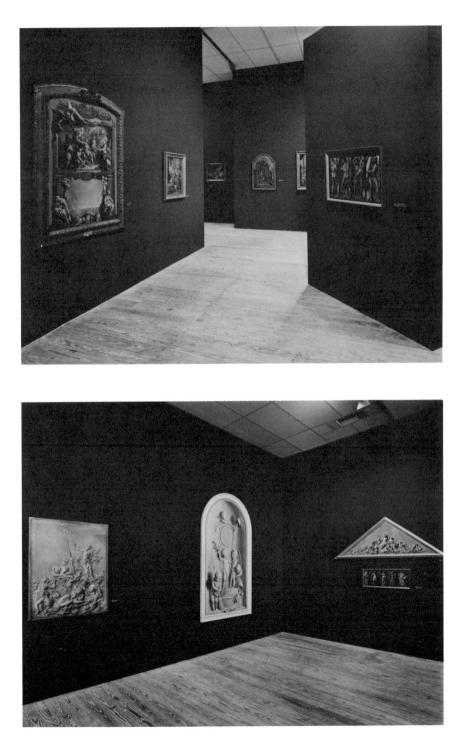

169

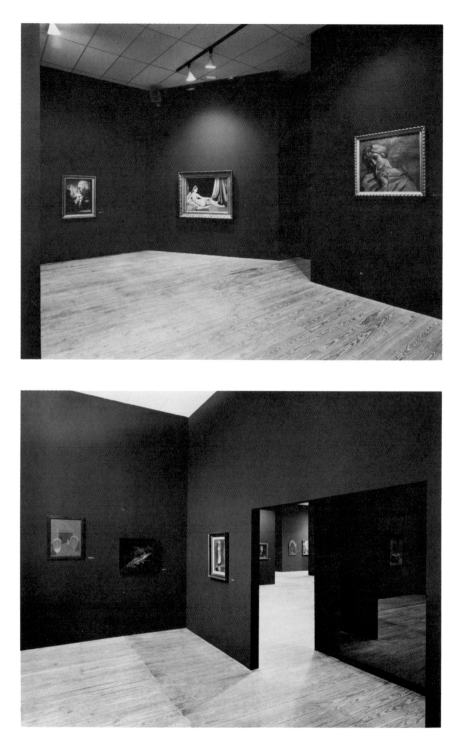

INDEX

artist, catalogue number(s)